The Art of
Painting in
Acrylic

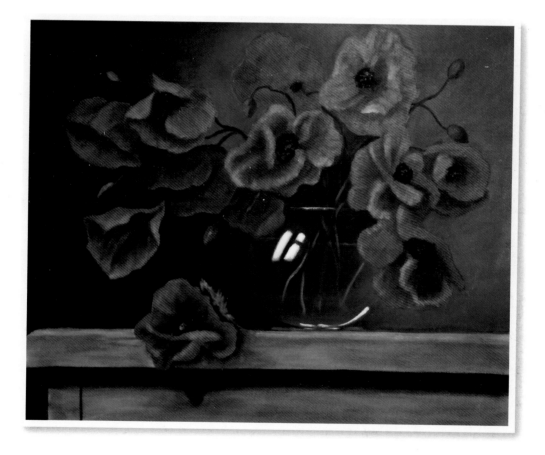

Artwork on front cover (center) and pages 6, 112, and 114–139 © 2014 Alicia VanNoy Call.
Artwork on front cover (top right) and pages 4 and 48–67 © 2014 Darice Machel McGuire. Artwork
on front cover (bottom right) and pages 90–111 © 2014 Michael Hallinan, except photograph on
page 102 © Shutterstock. Artwork on back cover and pages 3 and 68–89 © Toni Watts. Artwork
on pages 1, 16, and 18–33 © 2014 Linda Yurgensen, except photograph on page 26 © Shutterstock.
Photographs on pages 8 ("Paints," "Palettes") and 10 (color wheel) © Shutterstock. Photographs
on pages 8 ("Surfaces") and 9 ("Brushes") and artwork on page 11 ("Using Complementary
and Analagous Colors") © 2013 Patti Mollica. Artwork on pages 10 ("Mixing Neutrals") and
11 ("Understanding Value") © 2005 Lori Lohstoeter. Artwork on page 8 ("Exploring Color
Temperature") © Tom Swimm. Artwork on pages 12–13 © 2012 Vanessa Rothe. Artwork on pages
14–15 © Nathan Rohlander. Artwork on pages 34 and 36–47 © 2013 Varvara Harmon.

Authors: Alicia VanNoy Call, Michael Hallinan, Varvara Harmon, Darice Machel McGuire,
Toni Watts, Linda Yurgensen

Publisher: Rebecca J. Razo
Creative Director: Shelley Baugh
Project Editor: Stephanie Meissner
Managing Editor: Karen Julian
Associate Editor: Jennifer Gaudet
Assistant Editor: Janessa Osle
Production Artists: Debbie Aiken, Amanda Tannen
Production Manager: Nicole Szawlowski
Production Coordinator: Lawrence Marquez

www.walterfoster.com
3 Wrigley, Suite A
Irvine, CA 92618

Printed in China
10 9 8 7 6 5 4 3 2 1
18720

The Art of
Painting in
Acrylic

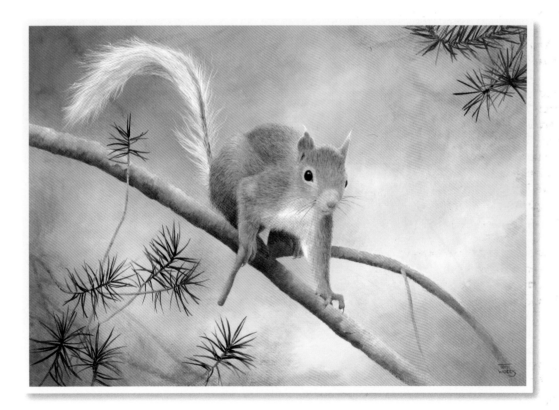

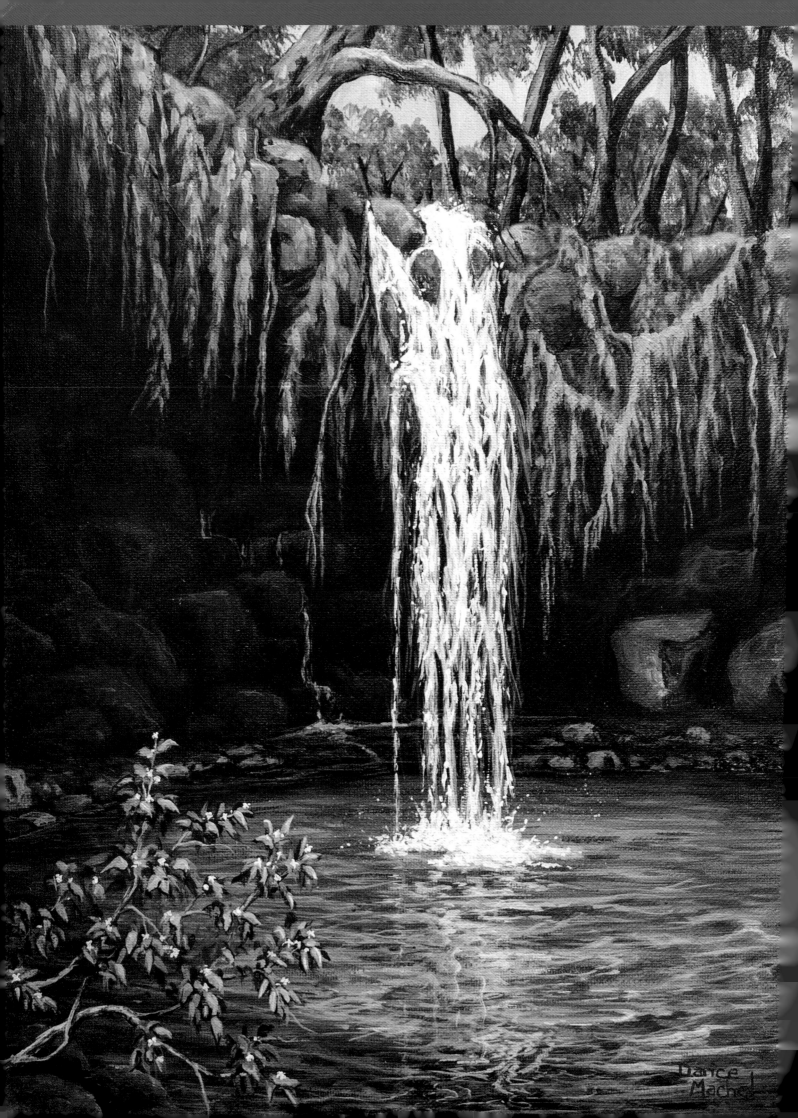

Contents

Introduction

Acrylic is a uniquely distinctive medium, with unparalleled versatility. While it has its own look and feel, it also beautifully mimics other media, such as watercolor, oil, and even pastel. Acrylic paint dries quickly like watercolor but is as permanent as oil and as vibrant as pastel. You can thin acrylic paint with water to create luminous washes, or you can use it straight from the tube to build up thick layers. And because acrylics are water-based, cleanup is as simple as soap and water.

Unlike other mediums, it's almost impossible to make a mistake with acrylics that can't be fixed. If there's an area that needs to be reworked, simply paint over it. Because this medium dries quickly and layers beautifully, you can keep on painting until you get it right—previous layers that may show through only add charm and character!

Acrylic is an ideal medium for capturing any subject matter—from animals and landscapes to still lifes and portraits. Each chapter in this book guides you through step-by-step lessons designed to help you master the art of painting in acrylic. From concepts to techniques to subject-specific tips, follow along with the expert insight and instruction of six talented artists.

Most of all, enjoy the painting process. One of the greatest joys in life is to unleash your inner creativity and watch a beautiful painting emerge before your eyes.

Tools & Materials

To get started with acrylic, you need only a few basic tools: paints, brushes, supports, and water. When purchasing supplies, try to buy the best you can afford. Better-quality materials are more manageable and produce longer-lasting works.

PAINTS

Acrylic paints come in jars, cans, and tubes. Most artists prefer tubes because it is easier to squeeze out the appropriate amount of paint onto your palette. There are two types of acrylic paints: student grade and artist grade. Artist-grade paints contain more pigment and less filler, so they are more vibrant and produce richer mixes. At the beginning of each project you'll find the palette of colors required to complete it.

PALETTES

Palettes for acrylic paints are available in many different materials—from wood and ceramic to metal and glass. Plastic palettes are inexpensive, and they can be cleaned with soap and water.

SURFACES

Acrylic paint needs a "toothy," porous, absorbent surface to which it can bind and adhere. For this reason, many surfaces need to be primed first to accept the paint. The most common primer is gesso, which prepares your surface to accept subsequent layers of paint. The most popular acrylic painting surfaces are pictured at right.

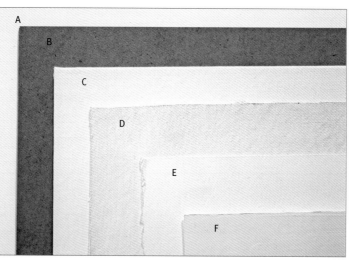

Traditional painting surfaces:
A. Canvas paper
B. Masonite or hardboard
C. Pre-primed canvas panels
D. Canvas
E. Watercolor paper
F. Primed mat board

BRUSHES

Acrylic paints and mediums can be applied with any brush. Paintbrushes are categorized by hair type (soft or stiff and natural or synthetic), style (filbert, flat, round, etc.), and size. It is a good idea to have small, medium, and large sizes of both soft and stiff (bristle) brushes. Synthetic-hair paintbrushes work well with acrylic, as the hairs are soft but springy enough to return to their original form. In addition to brushes, you may want to have a palette knife or painting knife on hand for mixing colors on your palette and experimenting with textural effects on your canvas. Care for your brushes by cleaning them after use with lukewarm water and soap or brush cleaner.

Basic Brush Shapes:
- Flats – long bristles that are squared off at the top
- Brights – short, squat bristles that are squared off at the top
- Filberts – long bristles that are slightly rounded at each corner
- Rounds – bristles that taper to a soft point at the tip
- Liners – long, soft bristles that taper to a very fine point
- Fans – fan shape that produces a "feathered" stroke for blending

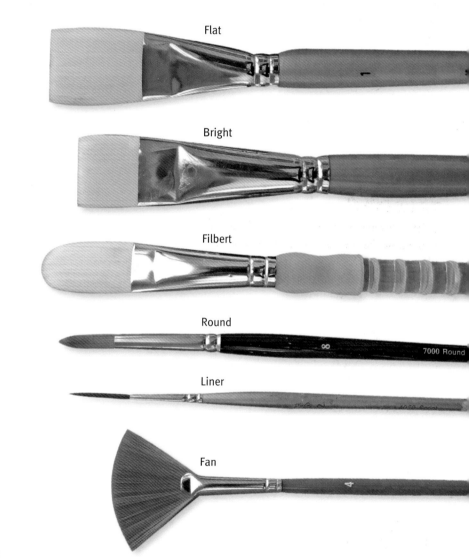

Flat

Bright

Filbert

Round

7000 Round

Liner

Fan

ADDITIONAL SUPPLIES

Some additional supplies you'll want to have on hand include:
- Paper, pencils, and a sharpener for drawing, sketching, and tracing
- Jars of water, paper towels, and a spray bottle of water
- Fixative to protect your initial sketches before you apply paint
- Acrylic mediums such as polymer gloss medium

Color Theory

Before you begin painting, it's important to know the basic principles of color theory. Color plays a huge role in the overall mood or "feel" of a painting, as colors and combinations of colors have the power to elicit various emotions from the viewer.

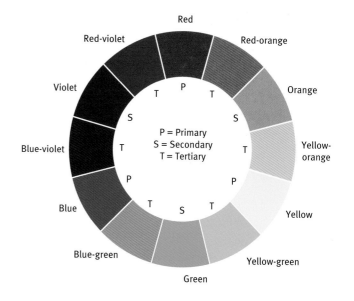

The Color Wheel This handy color reference makes it easy to spot complementary and analogous colors (see page 11), making it a useful visual aid when creating color schemes.

LEARNING THE BASICS

The color wheel is a circular spectrum of color that demonstrates color relationships. Yellow, red, and blue are the three main colors of the wheel; called "primary colors," they are the bases for all other colors on the wheel. When two primary colors are combined, they produce a *secondary color* (green, orange, or purple). When a secondary and primary color are mixed, they produce a *tertiary color* (such as blue-green or red-orange). The term *hue* refers to the color itself (such as blue or red), and *intensity* (or *chroma*) means the strength of a color, from its pure state (straight from the tube) to one that is grayed or diluted.

MIXING COLORS

In theory, you can mix every color you might need from the three primaries (red, yellow, and blue). But all primaries are not created alike, so you'll need to have at least two versions of each primary available to work with—one warm (containing more red) and one cool (containing more blue). (See page 11.) Two primary sets give you a wide range of secondary mixes. You'll also find that they produce a generous array of subtle, neutral shades when mixed.

MIXING NEUTRALS

Neutral colors (browns and grays) are formed either by mixing two complementary colors or by mixing the three primaries together. By altering the quantity of each color in your mix or by using different shades of primaries, you can create a wide range of neutrals for your palette. These slightly muted colors are more subtle than those straight from the tube, making them closer to colors found in nature. At left are a couple of possibilities for neutral mixes using the complements blue and orange.

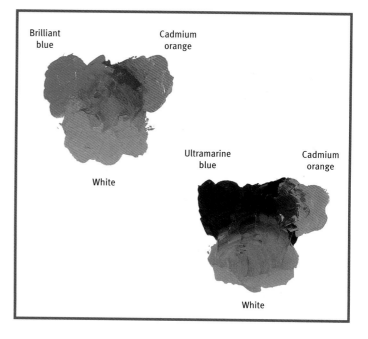

UNDERSTANDING VALUE

Value is the lightness or darkness of a color or of black. Variations in value are used to create the illusion of depth in a painting. Darker values generally tend to recede, while lighter values tend to come forward. With acrylic, artists lighten their colors with water or with a light color, such as white or Naples yellow, and they darken their colors by adding black or a dark color, such as burnt umber. Creating value scales like these will help you get a feel for the range of lights and darks you can create with washes of color. Apply pure pigment at the far left; then gradually add more water for successively lighter values.

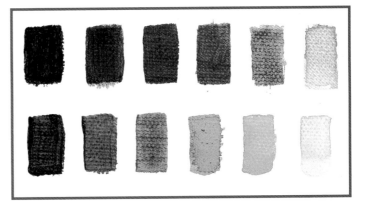

EXPLORING COLOR TEMPERATURE

The color wheel is divided into two categories: *warm colors* (reds, oranges, and yellows) and *cool colors* (blues, greens, and purples). Warm colors tend to pop forward in a painting, making them good for rendering objects in the foreground; cool colors tend to recede, making them best for distant objects. Warm colors convey excitement and energy, whereas cool colors are considered soothing and calm. Color temperature also communicates time of day or season: warm corresponds with afternoons and summer, and cool conveys winter and early mornings.

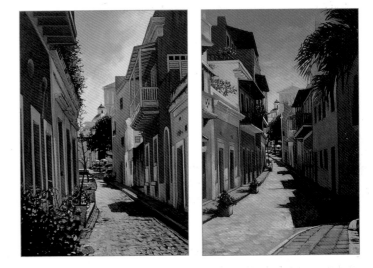

Seeing the Difference in Temperature At right are two similar scenes—one painted with a warm palette (left), and one painted with a cool palette (right). The subtle difference in temperature changes the mood: The scene at left is lively and upbeat; at right, the mood is peaceful.

USING COMPLEMENTARY AND ANALOGOUS COLORS

Complementary colors are any two colors that are directly across from each other on the color wheel (such as purple and yellow or orange and blue). When placed next to each other in a painting, complements create lively, exciting contrasts, as you can see in the example at right. *Analogous colors,* on the other hand, are adjacent to one another on the color wheel (for example, yellow, yellow-orange, and orange). Because analogous colors are similar, they create a sense of color harmony when used together in a painting.

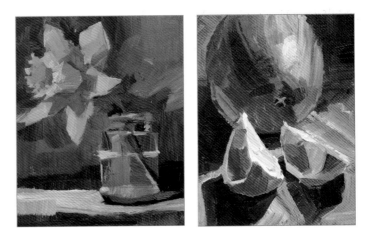

Working with Color Schemes At right are two still life scenes—one painted with a complementary color scheme (left) and one painted with an analogous color scheme (right). In the daffodil painting, the subdued purple takes up the most space but is balanced by the more saturated yellow of the flower. In the painting of the oranges, the lack of contrasting colors yields a simplistic look, but it has a simple elegance pleasing to the eye.

Drawing Techniques

While the focus of this book is on painting, it's important to hone your drawing skills so you can set yourself up for a successful painting from the start.

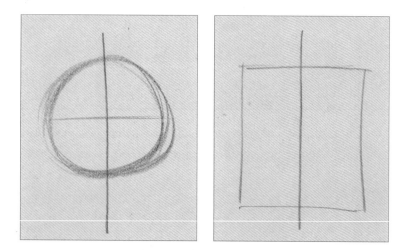

USING A CENTERLINE

Using a centerline when drawing shapes can help you achieve accurate measurements and symmetry. Before sketching a basic shape, draw a vertical and/or horizontal line; then use the guideline to draw your shape, making sure it is equal on both sides. Remember: Drawing straight lines and uniform circles takes practice and time. As you progress as an artist, these basic skills will improve.

ESTABLISHING PROPORTIONS

To achieve a sense of realism in your work, it's important to establish correct proportions. Using centerlines, as shown above, will provide starter guidelines. From there, you must delineate the shape of the object. To do this accurately, measure the lengths, widths, and angles of your subject. Examine the vertical, horizontal, and diagonal lines in your subject and make sure they relate properly to one another in your drawing. You can check proportions and angles by using your pencil as a measuring tool. Use the top of your thumb to mark where the measurement ends on your pencil (A, B), or hold it at an angle to check your angles (C, D).

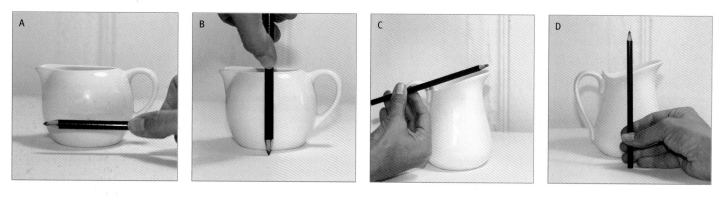

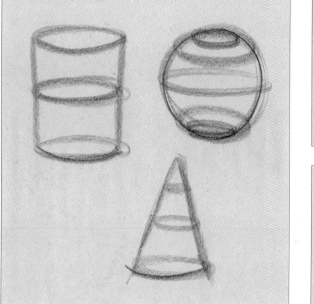

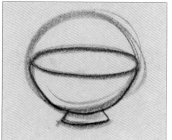

DRAWING THROUGH

You can transform basic shapes into forms by "drawing through" them. Imagine the form is transparent, and then suggest the surface of the backside in your sketch. This process will help you acknowledge the volume of your object as you add the surface shadows in later stages. It will also help you understand your object as it relates to its surroundings.

VALUES & SHADOWS

There are five main aspects of value that are used to create the illusion of volume. As mentioned previously, value refers to the tones of lightness and darkness, covering the full range of white through shades of gray to black. The range of lights and darks of an object can change depending on how much light hits the object. With practice, you will develop a keen eye for seeing lights, darks, and the subtle transitions between each value across a form. The five main values to look for on any object are the cast shadow, core shadow, midtone, reflected light, and highlight, as illustrated at right.

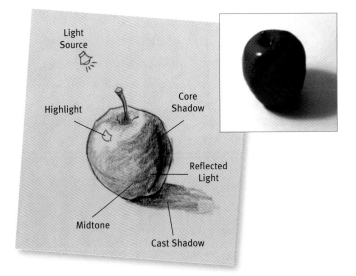

Light Source

Highlight

Core Shadow

Reflected Light

Midtone

Cast Shadow

1. **Cast Shadow** This is the shadow of the object that is cast upon another surface, such as the table.
2. **Core Shadow** This refers to the darkest value on the object, which is located on the side opposite the light source.
3. **Midtone** This middle-range value is located where the surface turns from the light source.
4. **Reflected Light** This light area within a shadow comes from light that has reflected off of a different surface nearby (most often from the surface on which the object rests). This value depends on the overall values of both surfaces and the strength of the light, but remember that it's always darker than the midtone.
5. **Highlight** This refers to the area that receives direct light, making it the lightest value on the surface.

FOCUSING ON CAST SHADOWS

Every object casts a shadow onto the table, chair, or surface that it sits upon (called the "cast shadow" as explained above). The shadow will fall to and under the dark side of the object, away from the light source. Including this shadow is very important both in depicting the illusion of form and in grounding your object, which gives the viewer a sense of weight and space. Note that these shadows are the darkest at the point where they meet the object (often beneath the object) and lighten as they move away from the object. Generally the shadow edge is also sharpest at the base of the object, softening as it moves away from the object.

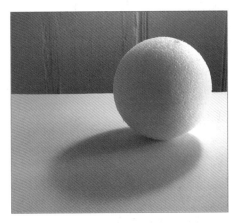

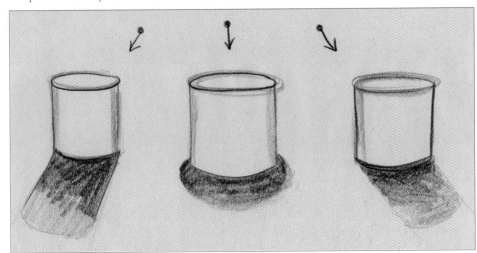

Painting Techniques

There are myriad techniques and tools that can be used to create a variety of textures and effects. By employing some of these different techniques, you can spice up your art and keep the painting process fresh, exciting, and fun!

Flat Wash Dilute acrylic paint with water. Lightly sweep overlapping, horizontal strokes across the support.

Graded Wash Add more water and less pigment as you work your way down. Graded washes are great for creating interesting backgrounds.

Drybrush Use a worn flat or fan brush loaded with thick paint, wipe it on a paper towel to remove moisture, and then apply it to the surface using quick, light, irregular strokes.

SAVE TIME—PLAN AHEAD!

Sketching Your Subject Taking an extra moment to prepare before you paint will ensure successful results and will save you time. For example, make a sketch of your subject before you begin applying washes.

Taking Precautions Keep tools on hand that might be helpful, like a ruler, artist's triangle, or straightedge that can be used as a guide. And be sure to have paper towels and lint-free rags handy, as well as an ample supply of water for rinsing, diluting, and cleaning up.

MORE BASIC TECHNIQUES

Thick on Thin Stroking a thick application of paint over a thin wash, letting the undercolor peek through, produces textured color variances perfect for rough or worn surfaces.

Dry on Wet Create a heavily diluted wash of paint; then, before the paint has dried, dip a dry brush in a second color and stroke quickly over it to produce a grainy look.

Impasto Use a paintbrush or a painting knife to apply thick, varied strokes, creating ridges of paint. This technique can be used to punctuate highlights in a painting.

Scumble With a dry brush, lightly scrub semi-opaque color over dry paint, allowing the underlying colors to show through. This is excellent for conveying depth.

Stipple Take a stiff brush and hold it very straight, with the bristle-side down. Then dab on the color quickly, in short, circular motions. Stipple to create the illusion of reflections.

Scrape Using the side of a palette knife or painting knife, create grooves and indentations of various shapes and sizes in wet paint. This works well for creating rough textures.

Mask with Tape Masking tape can be placed onto and removed from dried acrylic paint without causing damage. Don't paint too thickly on the edges—you won't get a clean lift.

Lifting Out Use a moistened brush or a tissue to press down on a support and lift color out of a wet wash. If the wash is dry, wet the desired area and lift out with a paper towel.

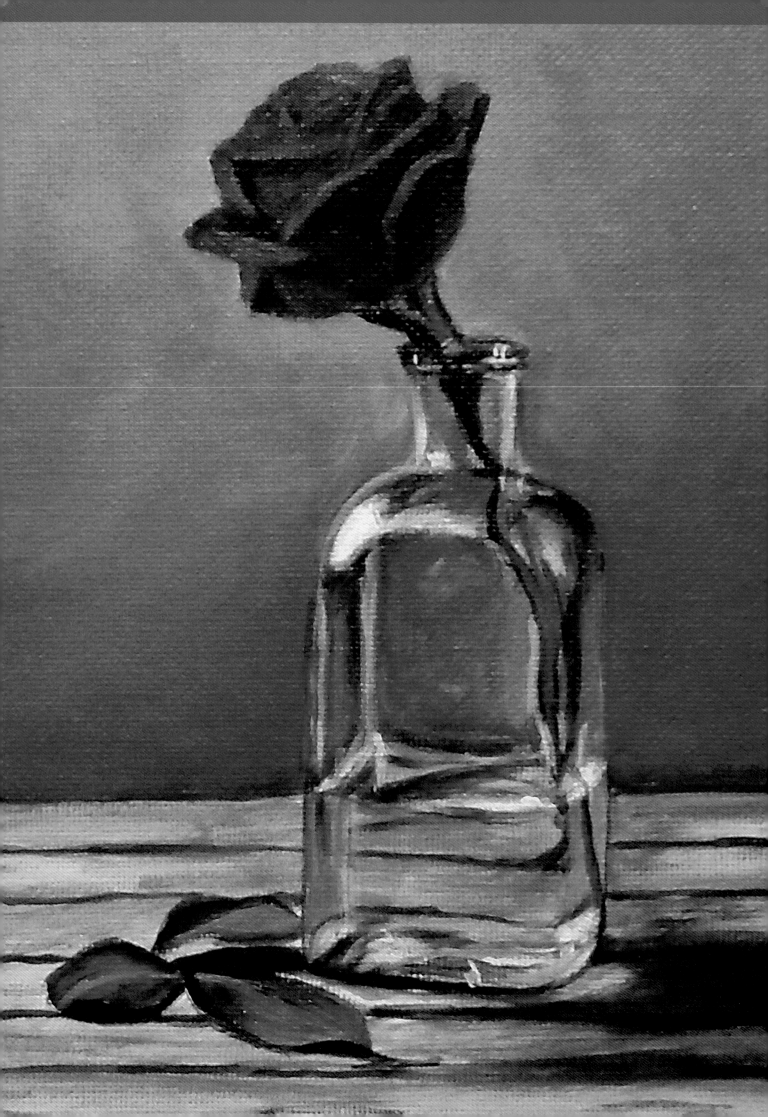

Still Lifes

with Linda Yurgensen

Still lifes and florals are the perfect place to begin your acrylic painting journey. Completely stationary, these subjects offer you the opportunity to truly study their compositions, shapes, shadows, textures, and colors. Follow along with the step-by-step projects in this chapter as artist Linda Yurgensen teaches you how to render glass, wood, flowers, and reflections.

Painting Glass

Many artists are intimidated by the prospect of painting glass. In this project I will demonstrate how it is no more difficult than painting the fruit in this photo. The beauty of acrylics is that because they dry so quickly, one can glaze on multiple layers of thinned paint—all in the same sitting. Glazing is what brings transparency to the glass and makes the object appear more real.

COLOR PALETTE

alizarin crimson, burnt sienna, burnt umber, cadmium yellow light, dioxazine purple, French ultramarine blue, Hooker's green, titanium white, yellow ochre

Optional: polymer gloss medium

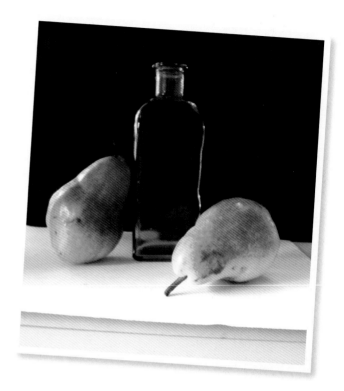

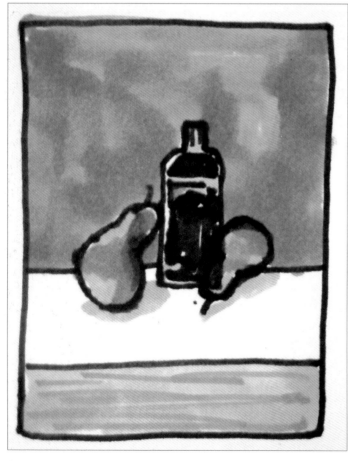

Step 1 I start with a small thumbnail sketch, establishing the composition and the orientation of the drawing on my canvas. It's helpful to shade in the middle and dark values at this stage with pencil, charcoal, or markers. Keep it simple. There is no need for detail at this point. I use two grayscale markers for the dark and middle values, and I leave the white of the paper for the lightest values.

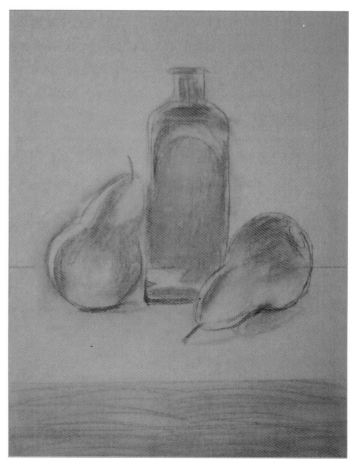

Step 2 I use a watercolor pencil to lightly sketch the main elements of the composition on the canvas. You can use a regular pencil too. I like to use a watercolor pencil because it is easy to correct errors; just dampen a paper towel and rub out the lines. I try to make the drawing fairly precise at this point, lightly shading the dark and middle values. I use my finger to rub the pencil marks until I have a shaded drawing.

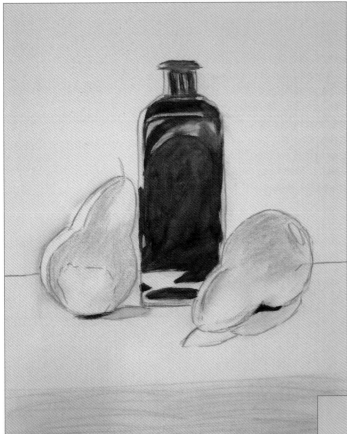

Step 3 I mix paint for the darks, using dioxazine purple, alizarin crimson, French ultramarine blue, and burnt umber for a rich purple, which will be the basis for all my darks. I use a #4 filbert brush and a little water to make a fairly thin puddle of paint to block in the dark values. As you continue to add layers, the paint will become darker; don't start too dark, as it is difficult to lighten later.

Step 4 I use the same dark mixture and a #8 flat brush to paint the dark background around the bottle. While the paint is still wet, I use a worn angle brush to smooth the edges around the pears and the bottle. I dampen the brush slightly with water and lightly blend the edges. Try not to have hard edges where one color transitions into another.

Step 5 I mix paint for the pears, using cadmium yellow light, yellow ochre, and titanium white. I keep the paint fairly thin with water and block in the midtone values on the pears with a #4 filbert brush. Be mindful of the value changes from light to midtone in both pears. The lightest value is where the light source hits the top of the pear on the left. Using a blend of burnt sienna, yellow ochre, and burnt umber, I paint a midtone reddish color on the pears. Then I use the angled brush to smooth the transitions between the yellow and red midtones.

Step 6 I start painting the bottle with a mix of dioxazine purple and Hooker's green, following my drawing and reference photo to properly establish the lights and darks. I thin the paint with a lot of water to keep it translucent on the lightest parts of the bottle. Then I smooth the brushstrokes and color transitions with the angled brush. I use a very thin mixture of cadmium yellow and titanium white to lightly paint the pears' cast shadows on the table. I add a little Hooker's green to the top of the left pear's shadow where some of the bottle reflects onto the table. I mix yellow ochre, burnt umber, and a bit of titanium white and paint the midtone of the bottom front edge of the table. I paint the top of the table with a mixture of a little yellow ochre and a lot of titanium white, using a #8 flat brush. As I paint, I smooth any harsh lines and use the dampened angle brush to blend transitions between colors, using a light touch so as not to remove too much paint.

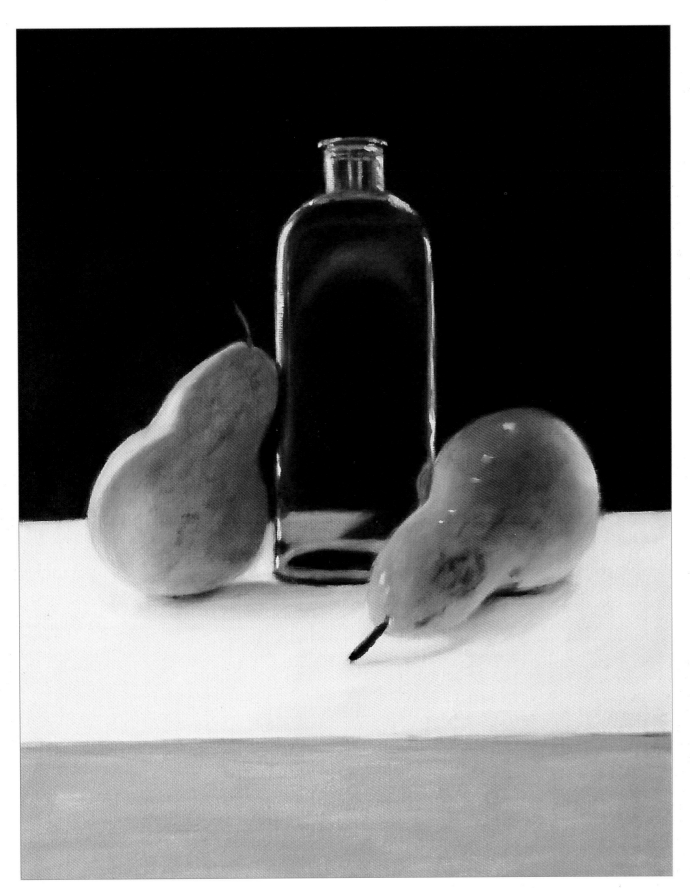

Step 7 I continue to glaze layers on the bottle and pears, using thicker paint in each consecutive layer. If you wish, you can begin using polymer gloss medium instead of water for mixing your paint. This medium helps bring vibrancy to the colors. I glaze over the background until I reach my desired color and opaqueness. Then I work over the entire painting, continually comparing it to the reference photo, until I am satisfied with the result. For the final touches, I paint the highlights on the pears and bottle, using a little titanium white and a #2 filbert brush. Once the painting is completely dry, I use a #8 flat brush to coat the entire painting with a thin layer of polymer gloss medium, which gives a nice gloss to the surface and brings back some of the dark colors that may look dull. Sign your painting and congratulate yourself on a job well done!

Beginning with a Monotone Underpainting

In this project we will explore how to paint a simple still life beginning with a monotone underpainting, sometimes referred to as a "dead" layer. This method has been used by some of the greatest painters in history and is very effective in achieving realism. The underpainting establishes a range of values and serves as the base for several layers of glazing. These layers of color produce depth and richness, creating a painting that appears to glow from within.

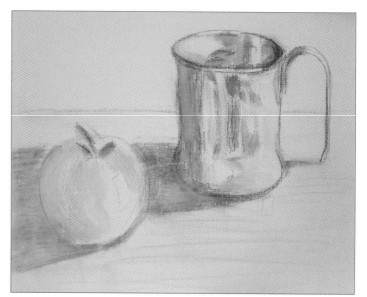

COLOR PALETTE

black, burnt sienna, burnt umber, cadmium red light hue, cadmium red medium, cadmium yellow light, dioxazine purple, titanium white, ultramarine blue

Optional: acrylic glazing medium, polymer gloss medium

Step 1 I use a watercolor pencil to lightly sketch the apple and mug directly onto the canvas. Once the drawing is complete, I shade the darkest values with the side of the pencil, using a dampened finger to rub the pencil marks into the canvas. I continue to work on the drawing, varying the smudges to indicate medium and light values.

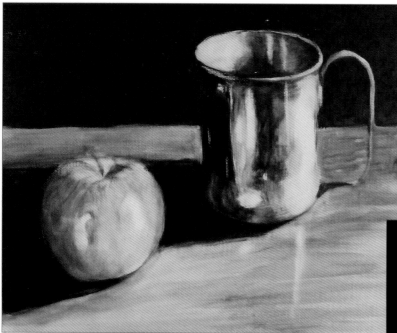

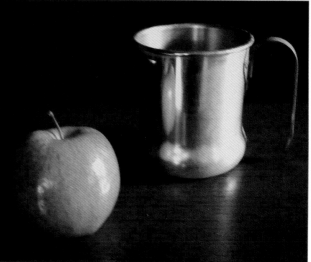

Step 2 When creating a monotone underpainting, it is helpful to first convert the reference photo to grayscale (right). Using black acrylic paint, I begin painting the variations of black I see in the photo, painting the darkest values with full-strength black. Then I paint the shadows of the apple and mug on the table, as well as the small shadow on top of the apple. I also paint the background behind the mug with full-strength black. I continue painting the rest of the mug and apple with various mixtures of black paint and water until the entire canvas is covered with varying values.

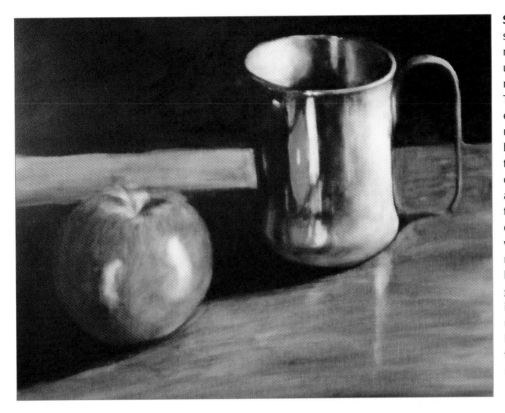

Step 3 I squirt a small puddle (about the size of a quarter) of glazing medium onto my palette. Using a mixture of burnt umber, ultramarine blue, and a lot of glazing medium, I paint over the darks in the cup. The paint should be very thin and transparent and barely leave any color over the dark underpainting. I like to use an old, worn brush to smooth out brush marks. I use this same color to glaze over the shadows on the table and apple as well. Then I mix a glaze of blue-gray by adding some white to my dark glaze and paint a thin layer over the center of the cup next to the dark value. I leave the right-hand side of the mug white; this is where the light source hits and is the lightest value. I use the blue glaze to paint the handle, as well as the inside of the mug. Then I paint the apple's reflection on the mug, using cadmium red light hue. As I work, I continually compare the photo to my painting and make any necessary adjustments in color.

Step 4 I mix a small glaze of cadmium red light hue and dioxazine purple and paint the darker value on the left side of the apple, keeping the paint transparent by using a lot of glazing medium and just a little paint. Next to this darker value, I glaze straight cadmium red light hue on the center of the apple and then add a bit of titanium white to this color for the right-hand side of the apple. Then, with the old brush, I smooth any brush marks and the transitions between colors. Be sure to leave the highlight areas on the apple unpainted. I paint a glaze of burnt umber mixed with burnt sienna over the entire tabletop, using a flat soft brush so that the paint spreads evenly.

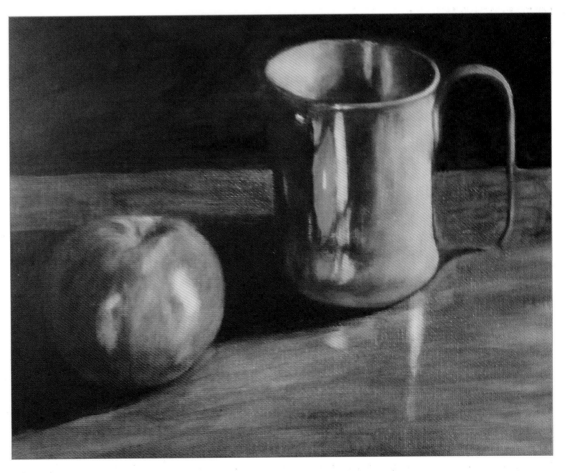

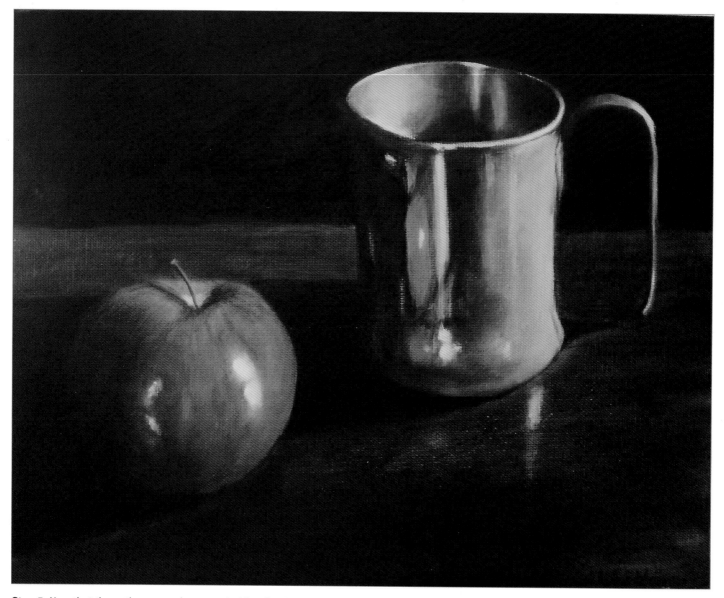

Step 5 Now that the entire canvas is covered with color, I can start to build up more layers. At this stage, the painting looks dull and washed-out, but it will start to come together as more layers of color are added. I strengthen the intensity of the apple by glazing more cadmium red medium and a bit of the cadmium yellow light all over it. If it gets too dark on the right side, gently lift off some of the color with a damp soft brush. I move to the mug and glaze cadmium red light hue over the right side and inside of the mug, being careful not to darken it too much. There should be just enough color in the glaze to warm up the mug with a hint of copper. I add another glaze of paint to the tabletop with the burnt umber and burnt sienna mixture, and I use a #2 round brush to lightly paint some lines on the table to suggest wood grain. I also use this brush to paint the apple stem.

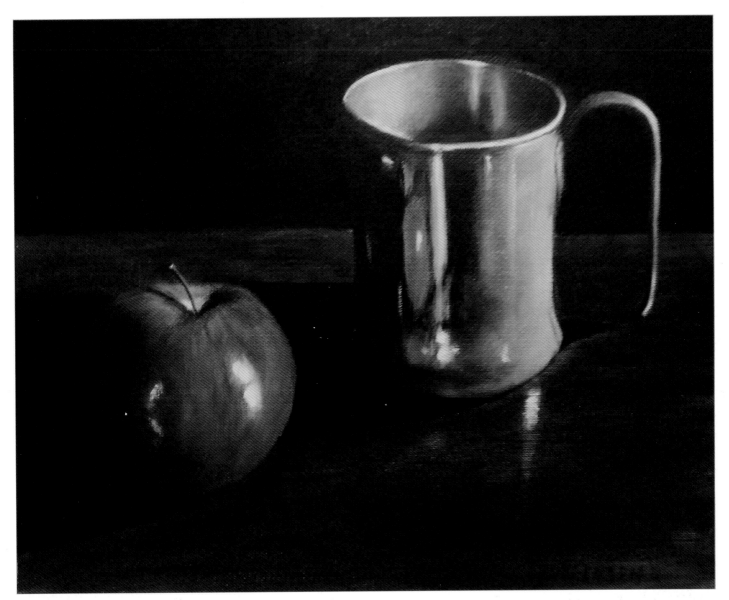

Step 6 The painting is coming together nicely now, but if it still lacks color intensity, I can glaze another layer onto the canvas. Continue putting glazes on your canvas until you are happy with the result. Lastly, I paint white highlights at the top of the mug and on the apple. When the painting is dry, I apply a thin coat of polymer medium with a flat soft brush to add vibrancy to some of the colors.

Using the Rule of Thirds

Even a simple still life can be exciting and dynamic with the right composition. One great principle of composition is the rule of thirds, which helps locate the *focal point,* or *center of interest.* To follow this principle, divide your canvas into thirds horizontally and vertically, and place the center of interest at or near one of the points where the lines interest. The rule of thirds keeps your center of interest away from the extremes (corners, dead center, or very top) of the composition. The result is a piece that holds the viewer's attention!

COLOR PALETTE

burnt sienna, burnt umber, cadmium red light hue, cadmium yellow medium, naphthol crimson, sap green, titanium white, ultramarine blue

Optional: polymer gloss medium

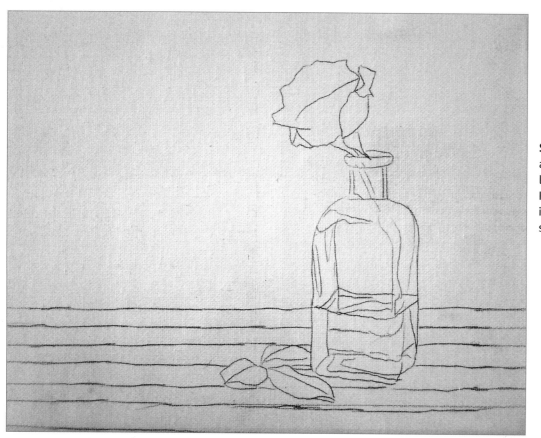

Step 1 I sketch directly onto an 8" x 10" canvas with a soft lead pencil or watercolor pencil. I make my sketch fairly precise, indicating the different value shifts on the rose and bottle.

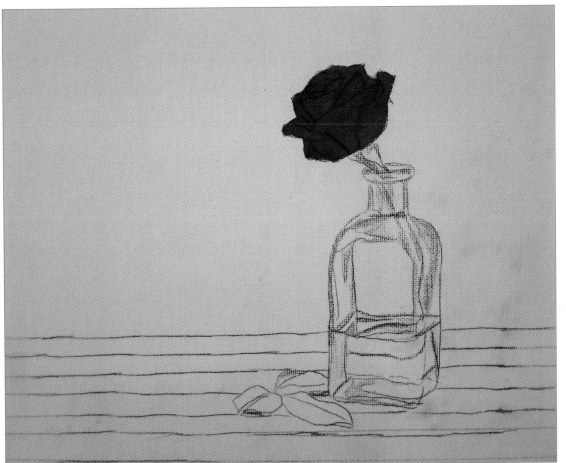

Step 2 I use a watercolor pencil to lightly shade the darkest values. Then I make a thin mix of cadmium red and naphthol crimson to block in the rose; this color serves as the rose's middle value. These pigments are transparent, so I can still see the pencil lines underneath.

Step 3 I continue to paint the rose, comparing the reference photo to my canvas. I mix a dark-value rose color with ultramarine blue and a bit of burnt umber. I paint the darks as I see them in the photo. Then I blend harsh lines gently with a soft brush before the paint dries. Since the tops of the rolled edges on the rose appear lighter, I paint these with a mix of naphthol crimson and a little cadmium yellow medium. I continue glazing colors onto the rose until I am happy with the results.

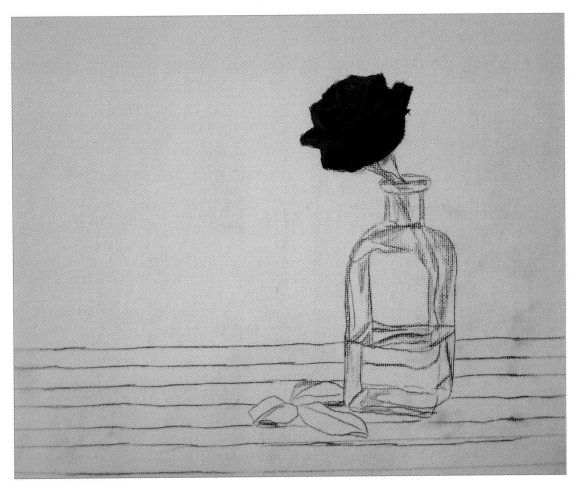

Step 4 I paint the darkest values of the stem first with full-strength sap green. Then I model the rest of the stem by mixing sap green with cadmium yellow medium to lighten areas as needed. I gently smooth the brush marks and transition areas with a soft, damp brush. Next I paint the background with a mixture of ultramarine blue, cadmium red light hue, burnt umber, and lots of titanium white. I use a soft brush with a bit of water to lay in the color behind the bottle and all over the background. Remember that the bottle is transparent but will still block some of the light, making the background behind the bottle appear a little darker.

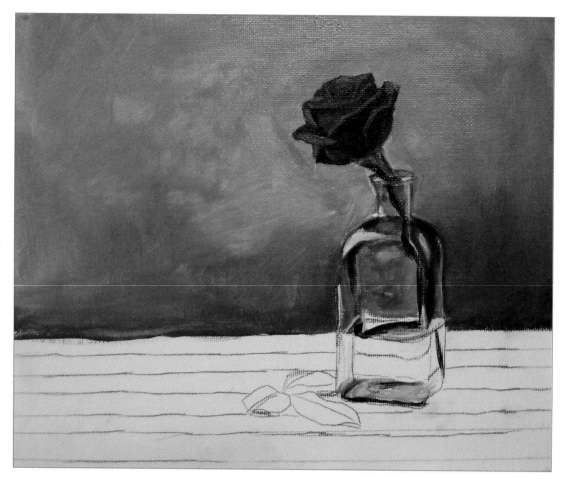

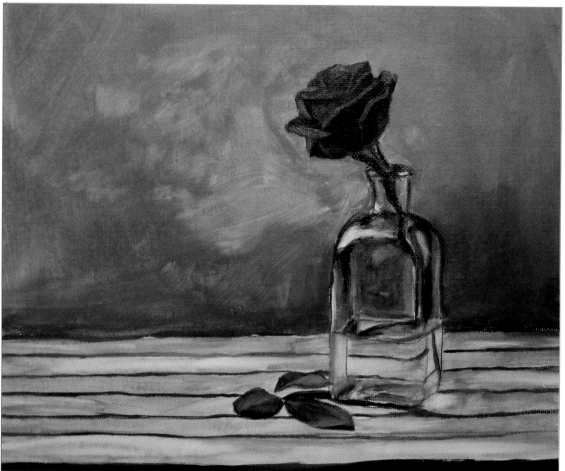

Step 5 I add ultramarine blue and titanium white to the green mix from step 4 to create lighter green values for the bottom of the bottle. I paint the leaves on the table with sap green and add cadmium yellow medium to lighten the color where needed. I use burnt umber to paint the small shadows under the leaves, as well as the lines on the table. When the lines are dry, I paint the tabletop with a very thin mixture of burnt sienna and titanium white, using a soft flat brush. I rub out the areas that I want to be lighter with a dry, stiff brush before the paint dries.

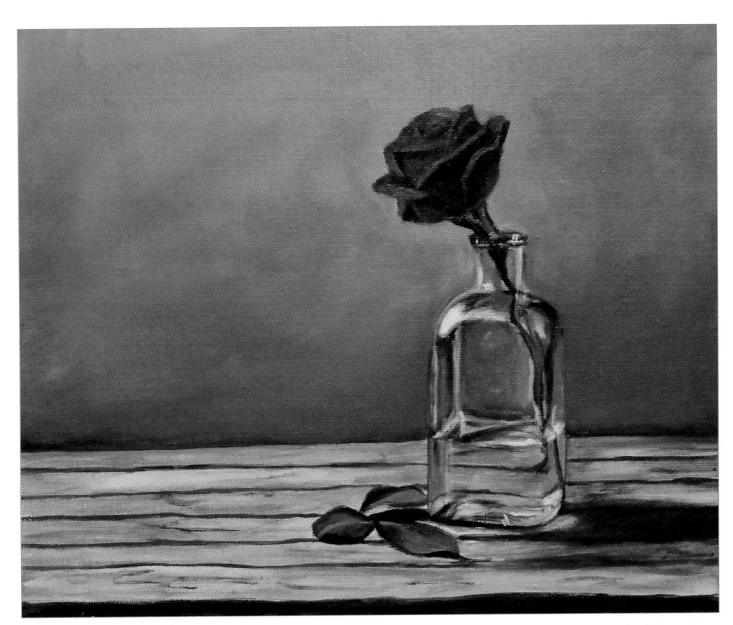

Step 6 Now that the entire canvas is covered with paint, it is easier to see where colors or values need to be adjusted. I notice that I lost some of the green in the bottle when I painted the background, so I glaze a very thin layer of sap green mixed with ultramarine blue and a lot of titanium white over the body of the bottle. I also paint a thin glaze of burnt umber on the table for the bottle's shadow and darken the shadow along the front of the table. I continue working all over the canvas, comparing my painting to the reference photo and adjusting colors and values as needed. When the painting is dry, I apply a thin layer of polymer gloss medium thinned with water over the entire painting.

Studying Other Works

This beautiful bowl of poppies is inspired by an oil painting. Studying artwork by artists you admire and mimicking their techniques is a great way to learn more about the painting process and explore various methods. As you develop as a painter, you'll be able to paint your own originals.

COLOR PALETTE

burnt umber, burnt sienna, cadmium red light, cadmium yellow medium, dioxazine purple, Hooker's green, naphthol crimson, titanium white, ultramarine blue, yellow oxide

Optional: acrylic glazing medium, polymer gloss medium

Step 1 First I lightly sketch the flowers and tabletop on a 16" x 20" white canvas. I create a fairly detailed sketch, especially for the flowers. I like to draw the value changes in the flowers, which will be helpful when I start to apply paint. I don't draw the stems and buds, as they will be covered by the first layer of paint.

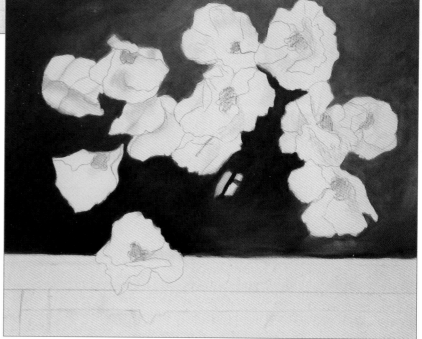

Step 2 I mix burnt umber and ultramarine blue with a bit of yellow oxide for a rich, dark olive green. I paint the darkest side of the background with this mix, using a #6 flat brush to carefully paint around the flowers. For the lighter side of the background, I mix yellow oxide with a tiny bit of the dark mixture. I use a soft angle brush to smooth the transitions between the two colors and to eliminate brush marks. I allow this layer to dry before painting a few more layers to develop an opaque, smooth, and cohesive background.

ARTIST'S TIP

The first layer of paint will be fairly transparent, and you may find that it takes several layers to achieve a smooth background. Continue painting the background until you are happy with the coverage, color, and texture. Just remember to let each layer dry completely before starting another. Use water to thin the paint as needed.

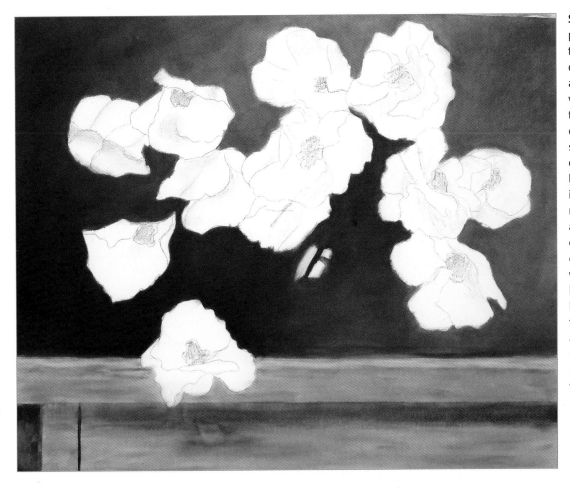

Step 3 Next I mix a thin puddle of paint for the table-top, using equal parts yellow oxide and burnt sienna. I use a flat wash brush to paint a very thin layer over the entire table. Before the paint dries completely, I gently scrub out some of the paint on the top edge of the table where the light makes it appear lighter in value. If you take off too much paint, simply glaze over another layer of the yellow oxide and burnt sienna mix. I continue to glaze the tabletop with the yellow oxide and burnt sienna mix until I am happy with the result. I allow the area to dry completely, and then I paint the shadows under the tabletop edge and under the flower on the table with thinned burnt umber.

Step 4 Next I use a mixture of cadmium red light and naphthol crimson to block in each flower. Since this mixture is fairly transparent, you should still be able to see your value sketch from step 1. This first mixture is the middle value. For the darkest values on the flowers, I mix cadmium red light with dioxazine purple and follow the underlying sketch as a reference. I use a soft brush to blend transitions between colors. For the lightest values, I add a little titanium white to cadmium red light. I mix burnt umber and ultramarine blue for the centers of the poppies.

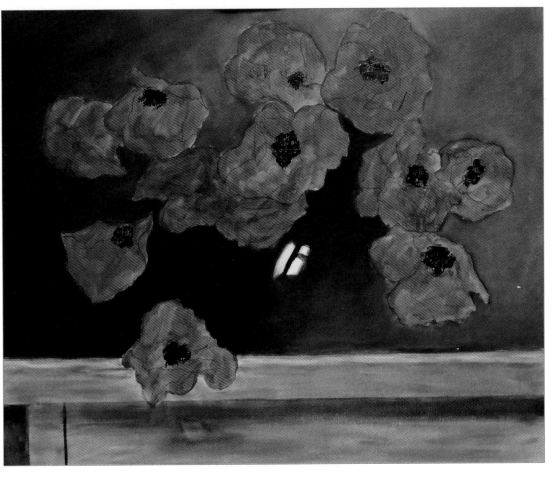

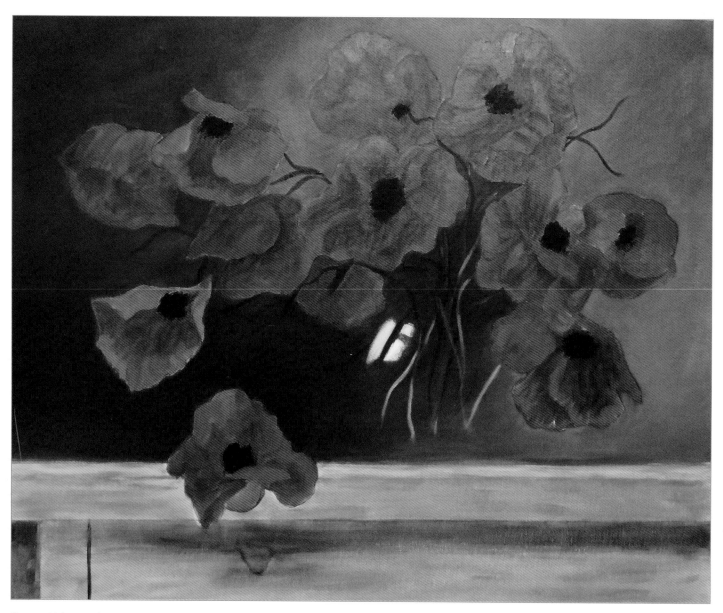

Step 5 Using Hooker's green and cadmium yellow medium, I begin to paint the stems. You can sketch them out first with a watercolor pencil if you wish, or you can loosely paint them directly onto the canvas. In the darker areas, such as within the glass bowl, I mix a little burnt umber into Hooker's green for a darker value. I use cadmium yellow medium on the highlighted sides of the stems.

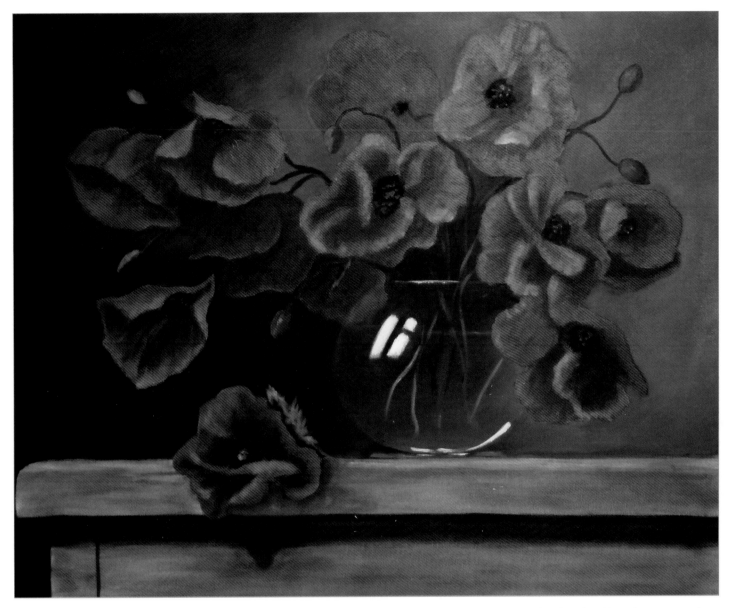

Step 6 I paint a few buds with cadmium red light mixed with burnt umber in the darker areas. I re-establish the glass bowl by using a watercolor pencil to lightly draw it on the canvas. To create the look of transparent glass, I thoroughly mix a tiny amount of titanium white into a quarter-sized dollop of glazing medium and use a soft angle brush to paint the inside of the bowl. You should see a filmy white glaze on the canvas that gives the illusion of looking through glass. If you are not successful at first, don't be discouraged; just wipe it off with a little water and try again. Acrylics are very forgiving, and it is easy to make corrections before (and even after) the paint dries. I continue glazing layers all over the canvas until I have rich, deep color throughout the painting. I finish by cleaning up the edges. When the painting is completely dry, I mix polymer gloss medium with a little water and apply a thin layer to protect and give nice shine and brilliance to the colors.

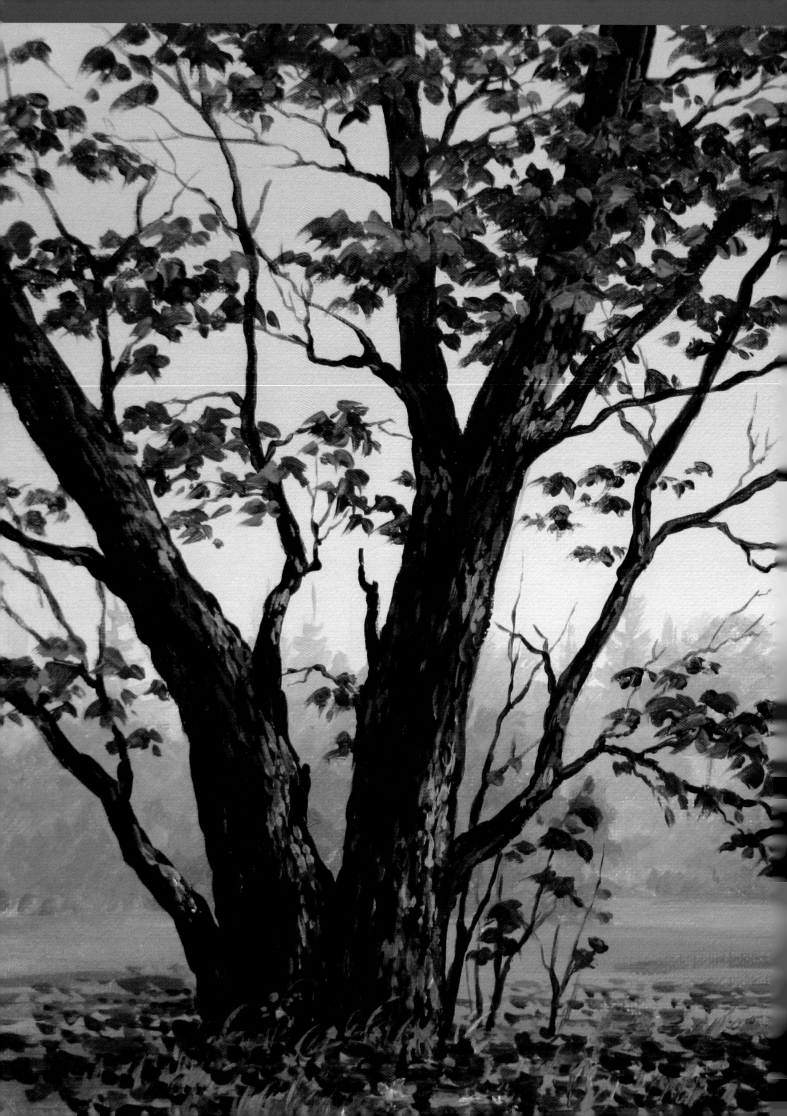

Landscapes & Seascapes

with Varvara Harmon & Darice Machel McGuire

It only takes a blank canvas and a few paint colors to create beautiful, vibrant landscapes and seascapes. In this chapter, expert artists Varvara Harmon and Darice Machel McGuire walk through step-by-step instructions for rendering six breathtaking scenes, including a snowy field, a beautiful Hawaiian sunset, and a waterfall. You'll explore how to suggest depth and distance, create crisp lines, and render various textures such as sand, water, and bark.

Painting Autumn Foliage with Varvara Harmon

Fall colors are vibrant and fun to paint. In this project we'll explore how to render fall foliage, as well as realistic tree bark.

COLOR PALETTE

alizarin crimson, burnt sienna, cadmium yellow medium, dioxazine purple, Grumbacher red, Hooker's green, Payne's gray, titanium white, ultramarine blue, yellow ochre

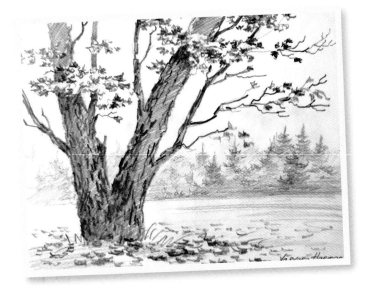

Step 1 First I create a small sketch to set the composition. Knowing the size of your canvas ahead of time makes it easy to establish the proportions of your sketch. For example, my canvas is 12" x 16", so my sketch is 6" x 8". You can choose any dimensions you like.

Step 2 Using a little ultramarine blue, I paint very light lines for the horizon, background forest, and foreground tree. These lines are very general; you do not need to get into too many details at this point.

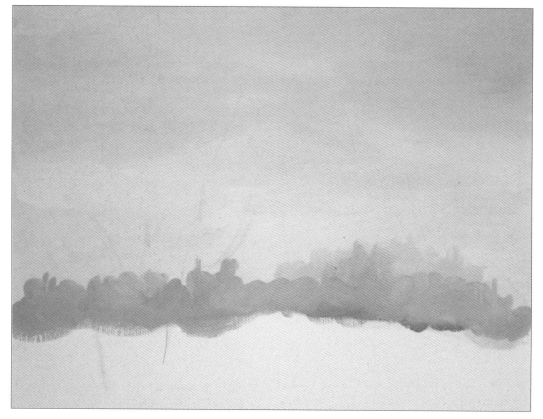

Step 3 I start working on the sky, using titanium white, ultramarine blue, alizarin crimson, and a little bit of Payne's gray to create the gray, foggy effect.

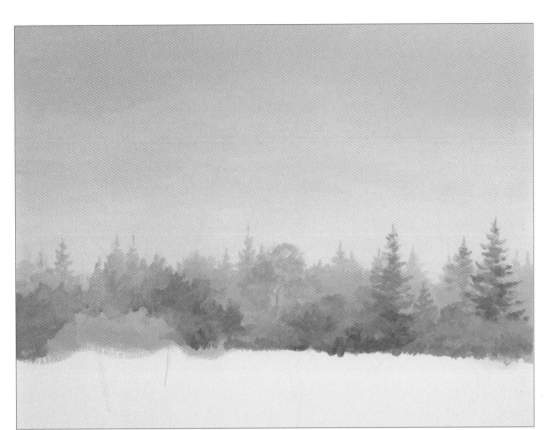

Step 4 Next I paint the background forest using all the colors I used for the sky, but I add a little bit of Hooker's green. I paint the trees farthest away light bluish-purplish colors and the closer trees darker, with some greenish and reddish hues to suggest autumn foliage. Remember that on a foggy day any objects in the distance will have predominantly light and midtone values and no contrast lines.

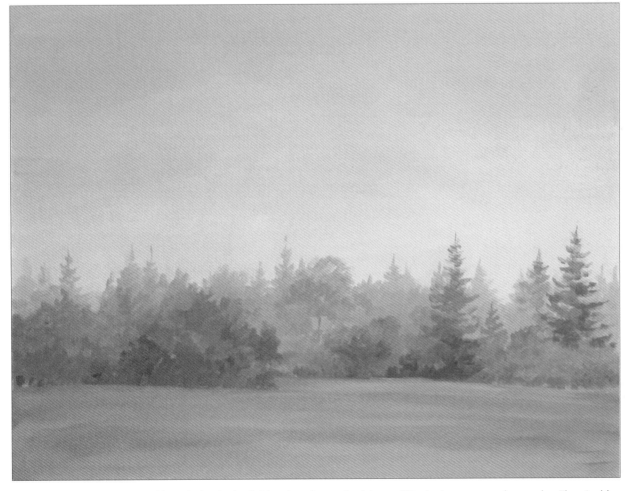

Step 5 I finish the background by painting in the field, using ultramarine blue and Hooker's green as a base color. Then I add some of the purple mixture I used for trees in step 4 to the more distant parts of the field and yellow ochre to the foreground to suggest distance.

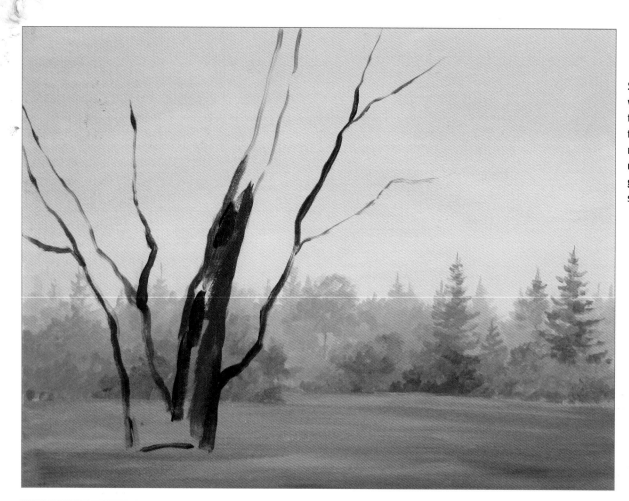

Step 6 I start working on the tree by outlining the trunks and the major branches using Payne's gray and burnt sienna.

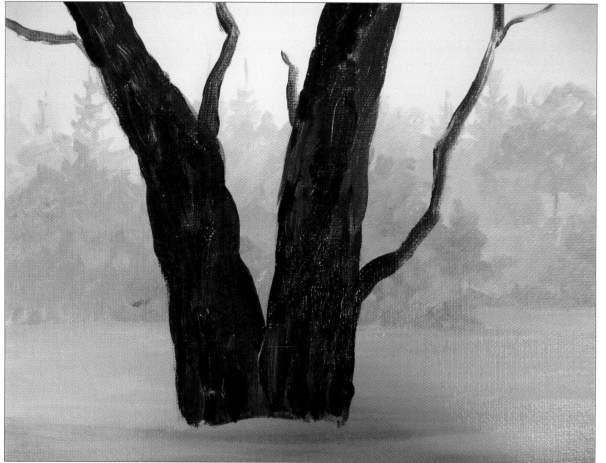

Step 7 I use Payne's gray and burnt sienna as the base colors of the trunks and branches. On the lighter (sunlit) side, I use more burnt sienna, while on the shaded side, I use more Payne's gray.

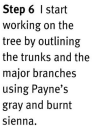

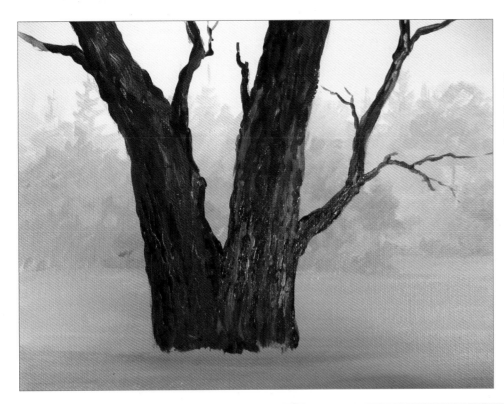

Step 8 I continue working on the tree, adding vertical lines of burnt sienna and ultramarine blue to create the effect of cracks in the tree bark. I also add yellow ochre lines on the lighter side of the tree.

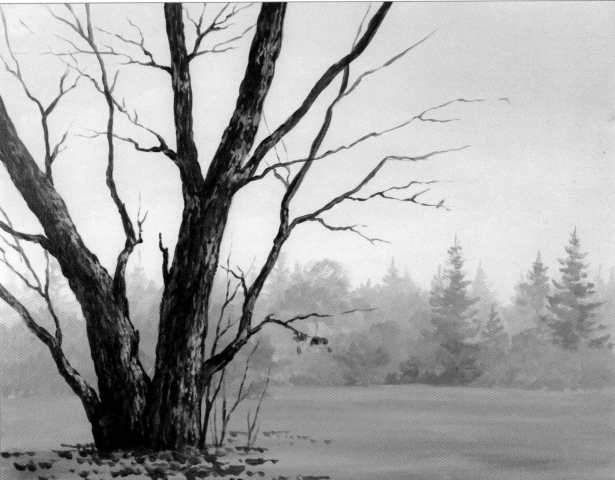

Step 9 I finish the tree by adding moss to the trunks and major branches. I combine a bluish-grayish mixture of ultramarine blue, Payne's gray, and titanium white for the shaded sides and a greenish-yellowish mixture of yellow ochre, Hooker's green, and titanium white for the lighter sides. I also start the leaves on the branches and on the ground, using a mix of Payne's gray, dioxazine purple, and alizarin crimson.

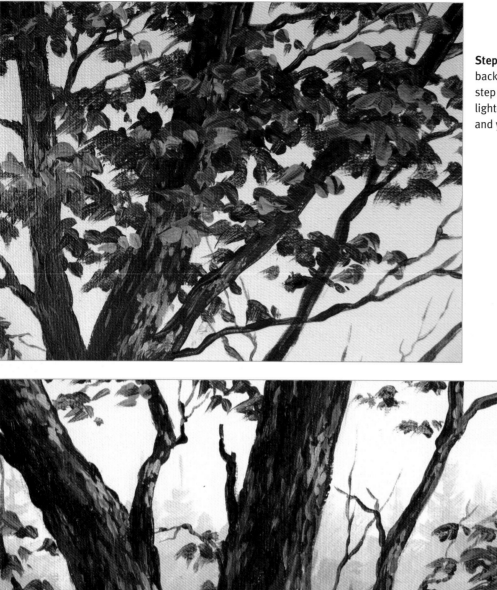

Step 10 I continue painting foliage. On the background leaves I use my leaf mix from step 9. For the foreground leaves, I use a lighter mix of burnt sienna, Grumbacher red, and yellow ochre.

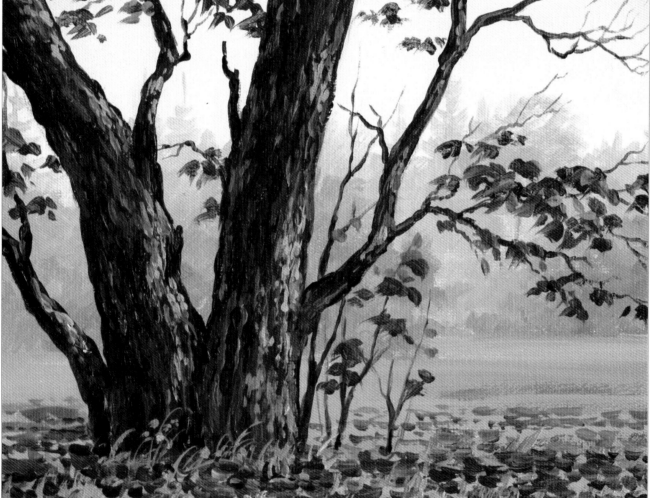

Step 11 Using the same paint combinations from step 10, I add leaves on the ground, along with some grass elements painted with Hooker's green and yellow ochre.

Step 12 I finish the painting by adding details of small branches using Payne's gray. Be sure to include some branches without leaves to achieve the desired autumn effect!

Producing Crisp Lines with Varvara Harmon

This bright red barn really stands out next to the white snow. When painting structures like this it's important to get clean, crisp lines. To do so, we'll work with removable tape.

COLOR PALETTE

alizarin crimson, burnt sienna, cadmium yellow medium, cerulean blue, Hooker's green, Payne's gray, titanium white, ultramarine blue

Step 1 After doing a brief sketch, I start with the sky. I use ultramarine blue, cerulean blue, alizarin crimson, cadmium yellow medium, and titanium white. For the sky closer to the horizon, I mix titanium white with cerulean blue and add ultramarine blue as I move up to the top of the canvas. While the sky is still wet, I mix titanium white, alizarin crimson, and cadmium yellow medium and paint the clouds.

Step 2 Next I paint in the background trees using a fan brush. Start the brush at the top of the tree and move down to create the tree's crown-shaped semicircle. I use a mixture of ultramarine blue, alizarin crimson, burnt sienna, and Payne's gray. Note that I have left an unpainted area on the right side of the canvas for the barn.

Step 3 I finish the background forest by adding some evergreen trees, using ultramarine blue, burnt sienna, and Hooker's green. These trees are in the distance, so the color will not be as bright and sharp; I keep them in midtone values.

Step 4 In the afternoon light, snow reflects the colors of the clouds in the setting sun. I therefore want to paint the snowy field using the same color palette I used for the clouds: titanium white, alizarin crimson, and cadmium yellow medium. In the shaded areas of snow, I add ultramarine blue to the mix, using less for the lighter areas and more for the darker shadow areas.

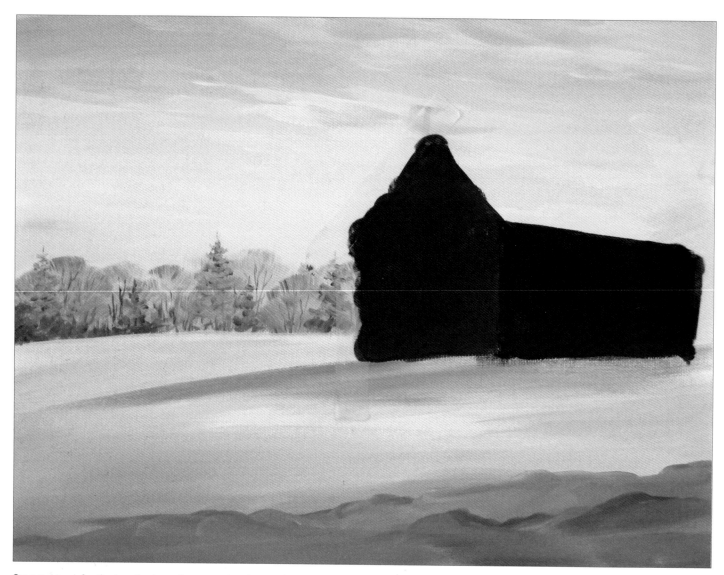

Step 5 I transfer the barn's shape from my sketch onto the canvas. Then I use removable tape (see step 6) to cover the space around the barn and protect it. Now I don't have to worry about detailing the straight edges of the barn's sides and roof. For the warm, sunlit side of the barn I use burnt sienna with a little bit of alizarin crimson and cadmium yellow medium. I use a mixture of burnt sienna, alizarin crimson, and ultramarine blue for the shaded front of the barn.

Step 6 When the paint is dry, I remove the tape. You can see how sharp and clean this leaves the edges of the barn against the background.

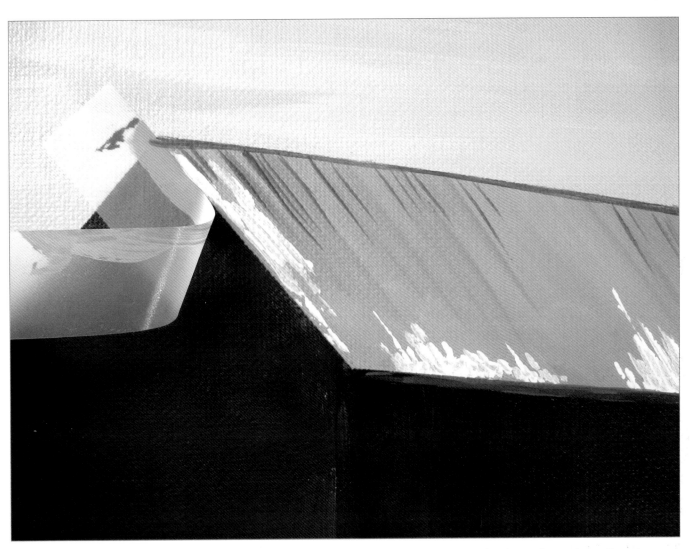

Step 7 I also use the tape technique to paint the roof. I use ultramarine blue, cerulean blue, alizarin crimson, burnt sienna, Payne's gray, and titanium white to create multiple shades of gray to paint the roof. Then I add dark gray lines and a little white for the snow. When the paint is completely dry, I remove the tape.

ARTIST'S TIP

You can paint the barn without taping the edges first, but this technique makes it much easier (and faster) to create strong edges.

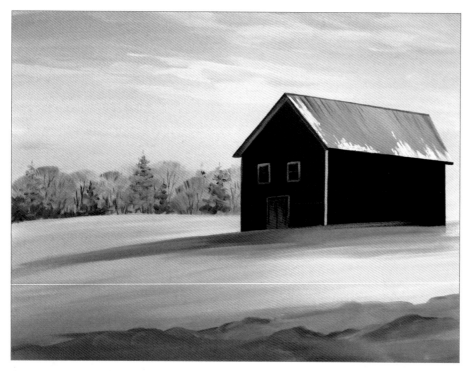

Step 8 Now I add some details to the barn, including the windows and door. For these details you can use any combination of the gray shades you used on the roof; just make them a little bit darker because they are in shadow. I also add some color to the walls of the barn to vary the texture and add visual interest.

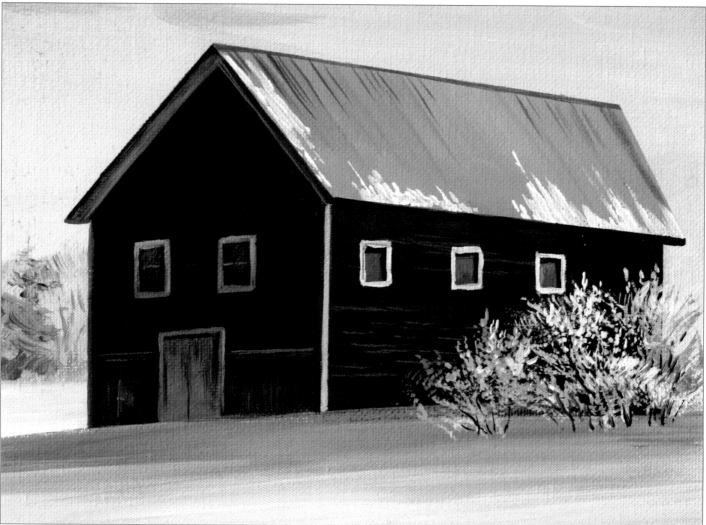

Step 9 Next I paint the snow-covered trees in front of the barn. I start by painting the branches with ultramarine blue, Payne's gray, and titanium white. Then I use Payne's gray for the trunks. I finish the trees by adding highlights on the light sides, using a very light mixture of titanium white, alizarin crimson, and cadmium yellow medium.

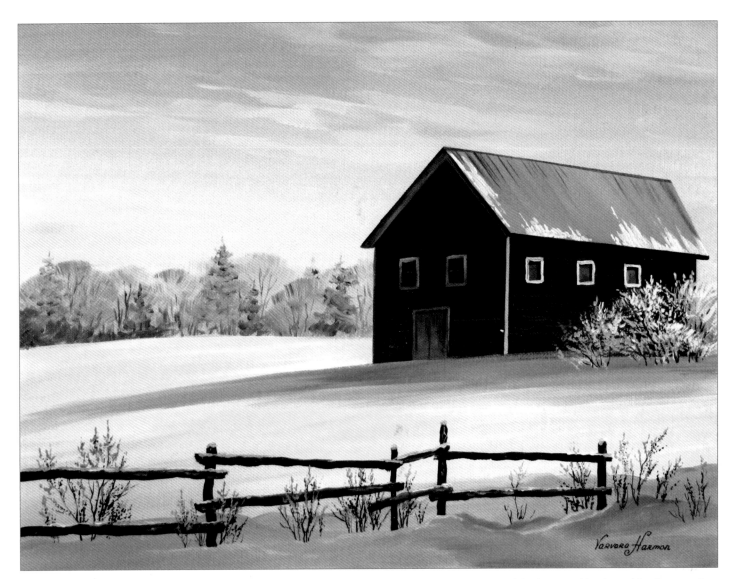

Step 10 In this last step, I add the fence and the small bushes in the foreground. I paint in the shape of the fence and bushes with mixtures of burnt sienna and Payne's gray. Then I add ultramarine blue and titanium white to the mixture and create some lighter details on the fence. As a finishing touch, I add some snow on the bushes and fence with a mixture of ultramarine blue and titanium white.

Creating Sand & Foam with Darice Machel McGuire

This sweet little beach is just a few blocks from where I live. Lucky for us, it's not a popular beach. It's quiet and clean with a stunning view of Moloka'i, the island, in the background. Most days, the Moloka'i peaks are covered in clouds, hiding the skyline of this beautiful island. In this painting we'll explore how to create sand and foam, two of my favorite textures.

COLOR PALETTE

burnt sienna, burnt umber, cadmium red medium, cadmium yellow medium, Payne's gray, phthalo blue, phthalo green, titanium white, yellow ochre

Step 1 I use a Conté pencil or vine charcoal to sketch the main components of the seascape, starting with the waterline against the island, approximately 3 ³/₄" from the top of the canvas. Make sure your line is straight.

Step 2 I mix titanium white and phthalo blue to create a light blue value, adding enough water to make the paint creamy. I brush in the mixture with a ³/₄" wash brush, using long, quick strokes going from edge to edge of the canvas. I allow this to dry. Then I add more titanium white to the mix and quickly brush long streaks across the sky. I mix cadmium red medium, Payne's gray, and titanium white in three varying values (dark, middle, and light) for the clouds. I start with the darker value to place the clouds, using a large filbert brush. I use the medium value to shape the clouds and the lightest value to highlight them. I then allow the painting to dry.

Step 3 I mix three gray values, using phthalo blue, Payne's gray, cadmium red medium, and titanium white. I use the medium value as the base color for the island in the background. I scrub in the entire island with a filbert brush. I allow the paint to dry, and then I add the darker and lighter values to create the valleys.

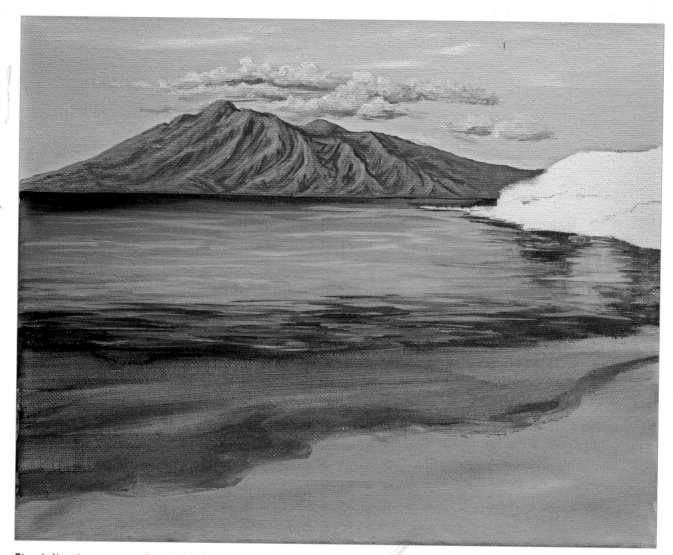

Step 4 Next I create an underpainting for the ocean and beach. This step needs to be worked fairly quickly, using thin washes and long brushstrokes with a wash brush. I paint the ocean, starting in the back, with phthalo blue and phthalo green. As I approach the foreground, I add titanium white, using the edge of my brush to create streaks of water movement. I add a mix of burnt sienna and phthalo green where the water and sand meet and for the darker shadows on the right. I add a little more burnt sienna to the shadow mix to paint the wet sand area. Then I paint the rest of the sand with a mix of burnt sienna and yellow ochre.

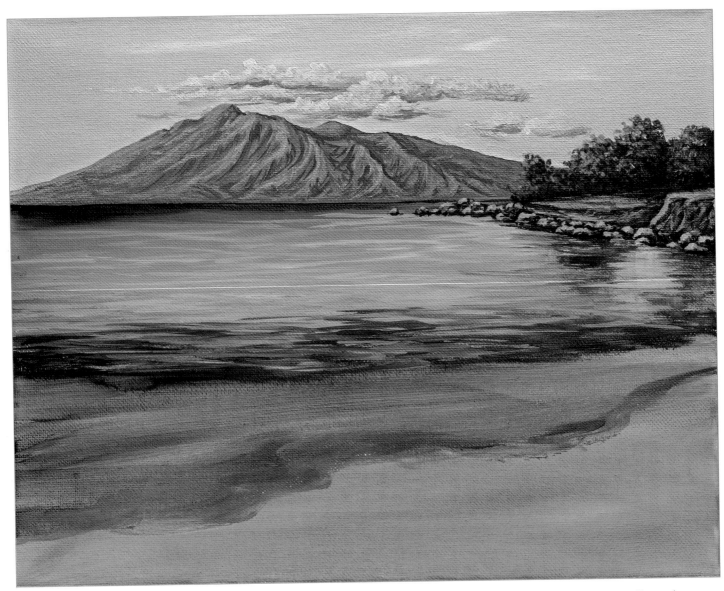

Step 5 I use Payne's gray and a small filbert brush to paint the rocks along the outcropping of land on the right. Then I mix a medium-value gray to shape rocks and add highlights with a mix of yellow ochre and titanium white. I paint the dirt and cliff with a base color of burnt sienna. I add shadows with a mix of Payne's gray and burnt umber and highlights with yellow ochre. Next I paint the grass with a mix of phthalo green and yellow ochre. I add more yellow for highlights and burnt umber for shadows. Moving on to the bushes, I start with the shadows, using a mix of Payne's gray, burnt umber, and phthalo green. I dab in the color with a small filbert brush. I add highlights by mixing in yellow ochre and cadmium yellow medium.

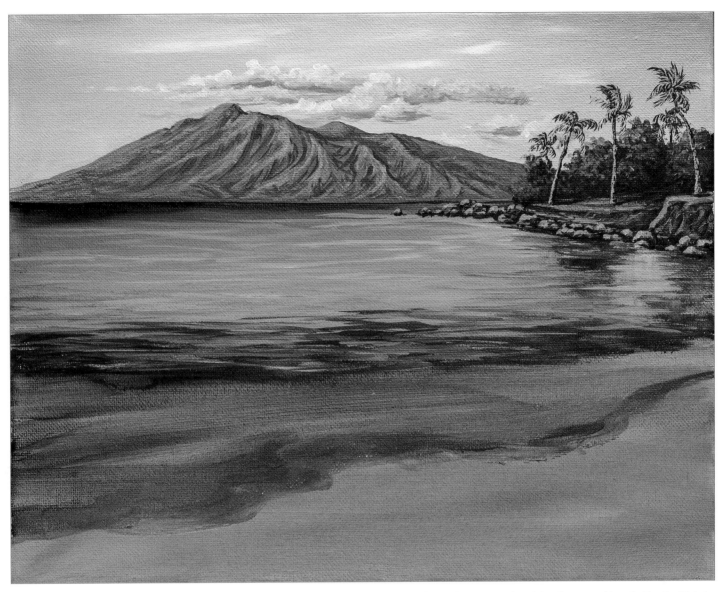

Step 6 Next I paint the palm trees. I mix burnt umber and Payne's gray and paint the five palm-tree trunks with a #00 round brush. For the highlights, I use yellow ochre mixed with titanium white. For the shadowed side of the palm fronds, I mix phthalo green, burnt umber, and Payne's gray. I mix phthalo green, cadmium yellow medium, and titanium white for the highlights. Then I allow my painting to dry completely.

Step 7 I add speckled texture to the sandy beach. Creating the illusion of sand is simple—and fun! Mask off the upper portion of the painting with craft paper or newspaper. Then mix shades of light and dark using these four colors: yellow ochre, burnt sienna, burnt umber, and titanium white. Add enough water to each color to make the paint inky in consistency. Load a toothbrush with one of the mixtures and rub your finger across the bristles to spatter the paint on the canvas. Repeat with each of the color mixes. Some of the spattered paint will create larger spots; you can turn those spots into small pebbles or rocks by adding shadows and highlights to them. When I'm done with the sand, I let the paint dry before removing the paper mask.

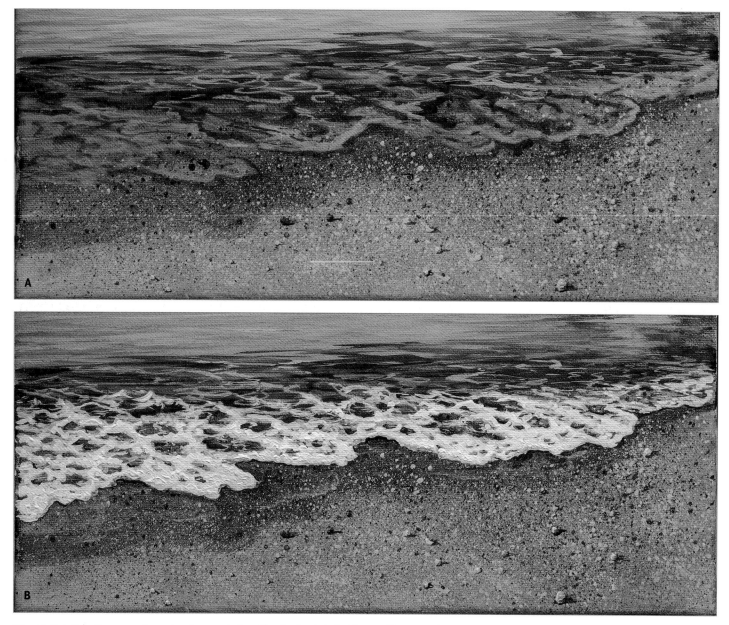

Step 8 Painting the ocean foam is a two-part step. First I mix phthalo blue and burnt umber and dilute the mixture to a very thin consistency. I scumble in this mixture between the water and sand area with a small filbert brush. This creates the dark undertone for the foam (A). Next I tint titanium white with tiny specks of phthalo blue, phthalo green, and burnt umber. Again, I add enough water to make a very thin paint and scumble it in with small filbert brush to create abstract patterns of foam. Then I add more white to the color mix to both lighten and thicken it. I build up the lighter paint in the areas closest to the shore, letting each layer dry between applications. To finish, I add shadows in the foam with a mix of phthalo blue and burnt umber (B).

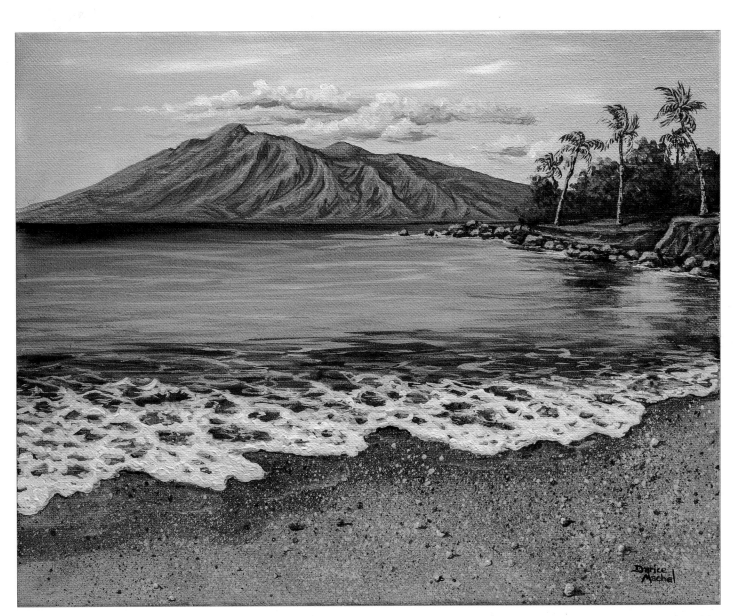

Step 9 I finish the painting by highlighting light splashes of water along the rocks on the right. Then I sign and varnish the finished piece.

Ho'okipa Sunset with Darice Machel McGuire

Ho'okipa is a favorite surfing beach on Maui. It offers big waves for surfers and big drama for the visual artist. Capturing this dramatic sunset was an exciting moment for me, and painting it allows me to re-experience that excitement. I chose to use a limited color palette for this painting. A limited palette allows the artist to mix a wide range of color values and shades—and eliminates the need to purchase dozens of colors.

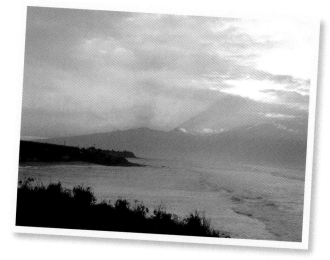

COLOR PALETTE

cadmium red medium, cadmium yellow medium, Payne's gray, titanium white, ultramarine blue

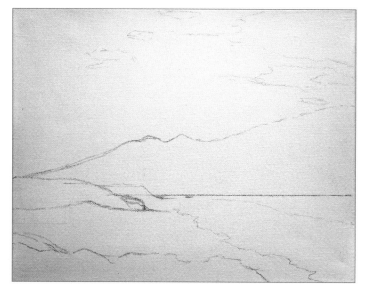

Step 1 I sketch the image on an 11" x 14" canvas with a Conté pencil or vine charcoal. I sketch the water line approximately 3 1/2" from the bottom of the canvas. I also lightly sketch in the areas of sky where I want my lightest colors to be.

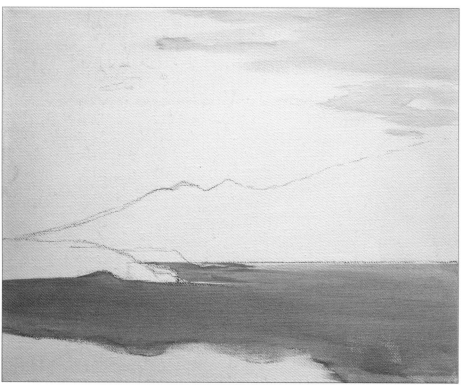

Step 2 Next I create an underpainting for the sky and ocean. I mix titanium white with a bit of Payne's gray for the upper right-hand corner of the sky, adding enough water to make the paint creamy. I use long, fluid strokes with a 3/4" wash brush, and then I allow it to dry. Next I add a touch of cadmium yellow medium to the mix and brush on a thin, transparent layer below the light gray. For the ocean, I mix cadmium red medium, cadmium yellow medium, and titanium white to create a peachy color. I thin it with water and paint the ocean area with long strokes.

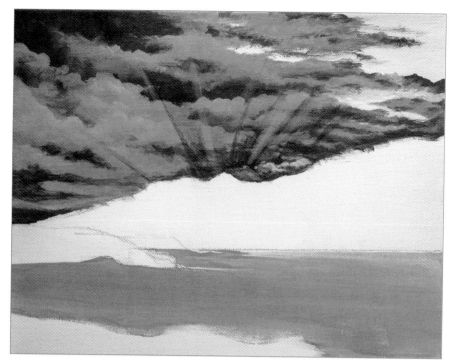

Step 3 For the darkest areas of sky, I mix ultramarine blue, cadmium red medium, and a touch of titanium white into a creamy, thick mix. I scrub it in with a large filbert brush, scumbling over the light gray area of sky to the right. I let the painting dry. Then I mix two medium values, one pinkish and one orange, using cadmium red medium, cadmium yellow medium, and titanium white. I scumble in both colors with a large filbert brush, overlapping them and blending and softening the edges with my finger. Using a round brush, I underline the clouds on the right with titanium white mixed with a touch of cadmium yellow medium. I lighten one of my medium values with white to add highlights in the clouds, again scumbling and blending with my finger. I let the clouds dry completely before painting the rays of light, using the lightest highlight colors and diluting the paint to make it very thin. I use a wash brush to add alternating wide strokes with the flat of the brush and thin strokes with the edge of the brush. You may need to go over the lightest rays a few times, but let each layer dry first.

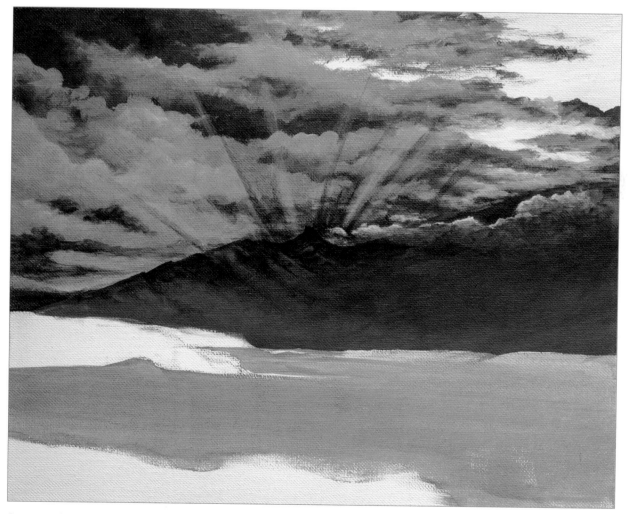

Step 4 I mix ultramarine blue with a touch of cadmium red medium, Payne's gray, and titanium white for the base color of the mountain. Using my wash brush, I scrub in the paint and allow it to dry. Then I add a little white to the mix for the misty areas, thin the paint, and scumble it in, adding hints of valleys along the left side of the mountain. Once satisfied with the look, I move on to the low clouds on the right. I use the same color mixes from step 3 to create these clouds, using very thin paint to maintain a transparent feel. I paint the clouds with a large filbert brush and blend with my finger. Then I outline the top edge with the highlight color, using a round brush.

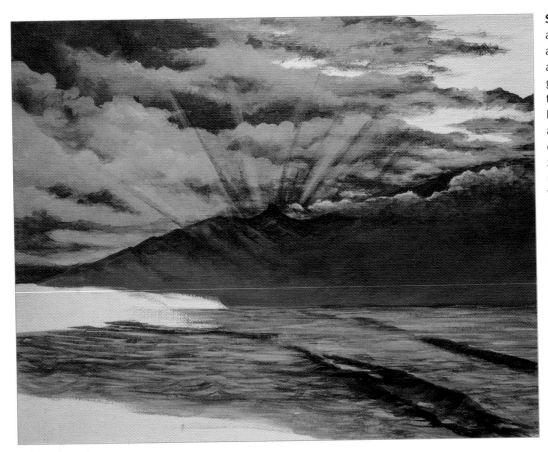

Step 5 Next I work on the ocean again, using very thin paint to create transparent layers. I start with a mix of ultramarine blue, Payne's gray, and titanium white to create the same value as the mountain. I use a wash brush to quickly apply the paint, using the edge of the brush to create the horizontal streaks. I allow the peachy underpainting to show through. When the paint is dry, I add more ultramarine blue to the mix to create a darker value as a base for the waves. I paint the waves, keeping their shape and curve in mind. Then I let the paint dry. Next I mix ultramarine blue and titanium white to create a lighter value, keeping the paint very thin. I use a small filbert brush to apply the color to the waves, using long and fluid brush strokes for the back portion and short, choppy ones for the foreground. Then I let the painting dry completely.

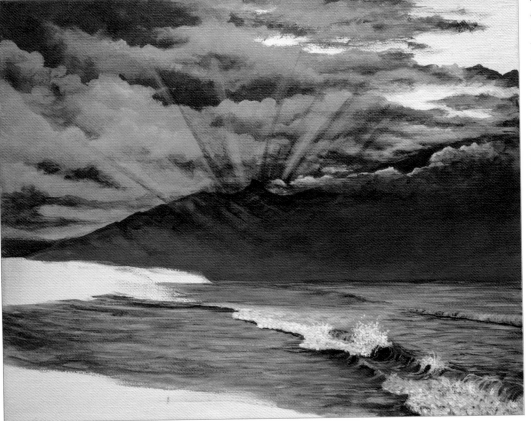

Step 6 I mix ultramarine blue and titanium white to a creamy consistency and apply to the back wave, making C-shaped strokes with a small filbert brush. Then I add a shadow under the wave. For the front wave and foam, I mix three lighter values of ultramarine blue and titanium white. This part requires various brushstrokes and paint consistencies for each value. Using a small filbert brush, I scumble, dab, blend, and drybrush to get the look I want. I use all three values to achieve depth and shape in the wave and foam. You can let each layer of value dry before adding another or try working them together. I add peachy highlights to the splash of the wave and shadows under the foam.

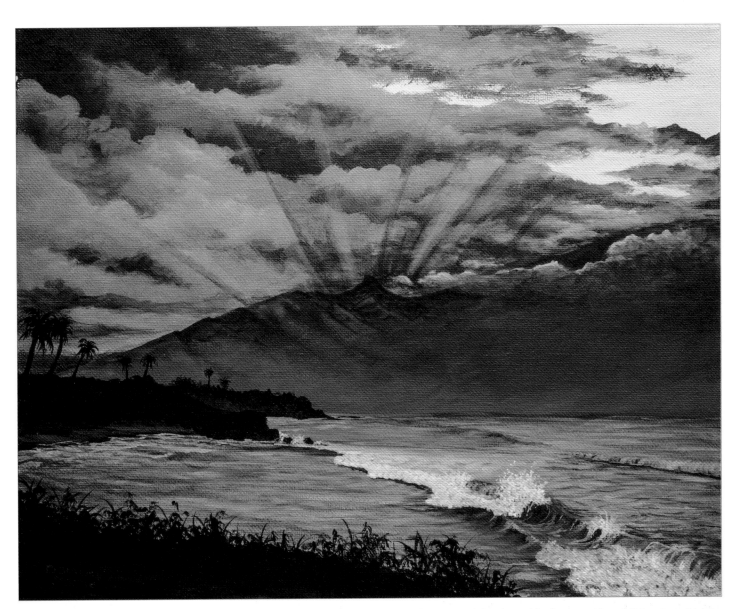

Step 7 For the beach, I mix cadmium red medium, cadmium yellow medium, Payne's gray, and titanium white for a muddy reddish color, which I apply with a filbert brush. For the silhouetted landscape, I mix Payne's gray, cadmium red medium, and ultramarine blue. The mix should be very dark and thick. I dab it on with a large filbert brush, letting the brush create the interesting shapes of rocks and bushes. I add a touch of titanium white to the mix and paint the mist between the land outcroppings, separating and enhancing the shapes of the rocks. I use a round brush in the foreground to paint the grass blades and palm trees. To finish off the beach, I mix another batch of ultramarine blue and titanium white and use a round brush to paint the waves on the shore. I let the beach dry and then paint the road in the lower corner, using the drybrushing technique with my beach color mix. I allow the painting to dry completely before varnishing.

Olowalu Valley with Darice Machel McGuire

I took this photo in an area called Olowalu on the west side of Maui. I was very lucky to witness the reflecting colors on the clouds over the mountains as the sun set behind me. Whenever I'm out photographing reference material for subjects, I look for interesting elements and compositions; this scene offered both. As I watched the changing colors, my mind was busy evaluating how I would paint the scene. I decided to use a red-orange underpainting to help retain the warm colors throughout the painting. In this project, I build the painting starting with the sky and painting dark to light, working my way down to the water.

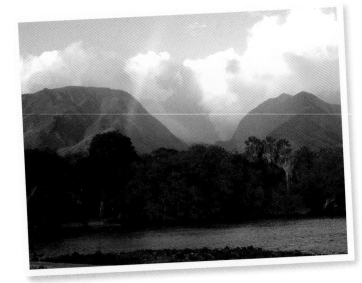

COLOR PALETTE

cadmium yellow, dioxazine purple, manganese blue, Payne's gray, phthalo blue, quinacridone red, quinacridone violet, sap green, titanium white, transparent red iron oxide (TRIO)

ARTIST'S TIP

Keep your paint layers thin to allow the red-orange underpainting and each layer of color to show through.

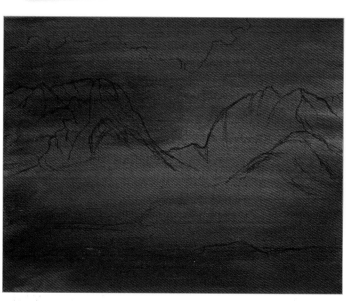

Step 1 I tone the entire canvas with a thin red-orange wash. This orange underpainting will help keep a warm color temperature throughout the painting. Once dry, I sketch in the scene, indicating shadow areas, the water line, and the outline of clouds. I opt not to sketch in the trees and bushes, as I will paint them to fit my composition; although, you may wish to loosely sketch them in now.

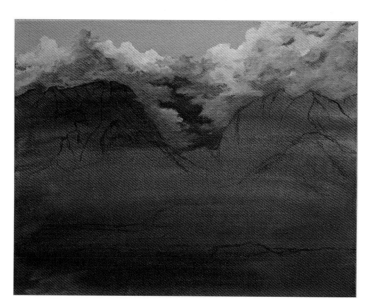

Step 2 I mix manganese blue and titanium white for the upper top-left of the painting, adding enough water to make the paint creamy. Then I brush it on with a wash brush, working from left to right with long, fluid strokes to prevent obvious brush marks. Next I mix dioxazine purple and manganese blue with a touch of Payne's gray and titanium white. I scumble this mix in the darkest areas of the clouds with a filbert brush. For the pink areas, I mix quinacridone violet, quinacridone red, and titanium white in various values, allowing them to mix on the canvas. I repeat the scumbling strokes for the yellow portion of the clouds, using a mix of cadmium yellow, titanium white, and a touch of quinacridone red.

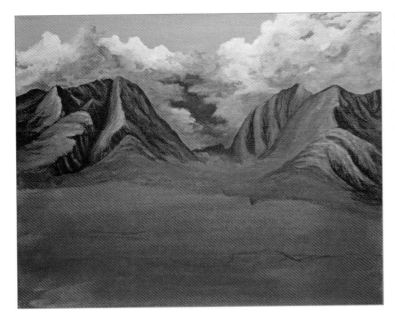

Step 3 I mix dioxazine purple, transparent red iron oxide (TRIO), and Payne's gray to create a blackish color for the dark mountain shadows. I keep the paint creamy and apply with a bright brush, following the angles of the shadows with my strokes. After the darks are painted, I set aside some of the dark mix and add titanium white to create a medium value. I paint next to the shadows, following the direction of the slopes. I paint the lighter highlights with a mix of TRIO and titanium white. For the more red areas, I use TRIO, quinacridone red, and titanium white. For the mist, I mix dioxazine purple and titanium white and thin it to a very watery consistency. I paint the mix onto the dry painting with a bright brush, using my finger to blend.

ARTIST'S TIP

I use wet paint for the sky, keeping each layer transparent, and often use my finger to blend the colors and soften the edges.

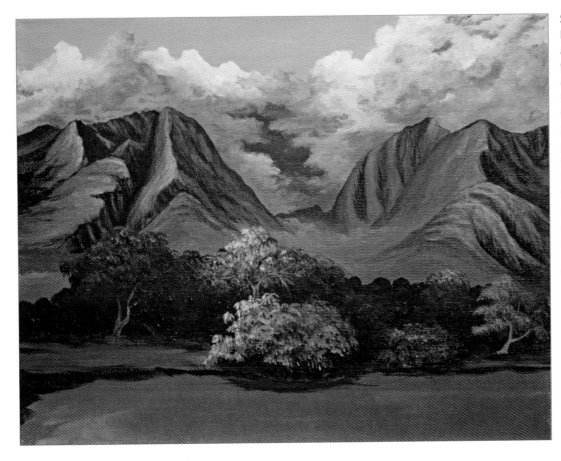

Step 4 I move on to the foliage. I mix sap green, Payne's gray, and a touch of dioxazine purple for the darkest shadows and dab in the color with a filbert brush. I add cadmium yellow to the mix to create a lighter value, and I work dark to light to create separation and shapes of the trees and bushes. For the lightest highlights, I use a mix of cadmium yellow with just a touch of sap green. Then I add the trunks and branches with a mix of TRIO and a touch of sap green and titanium white. I add Payne's gray to the mix for the shadows of the trunks. For the red tree, I mix TRIO and dioxazine purple for the shadow areas and TRIO and cadmium yellow for the highlights. I dab in the colors with a filbert brush. Then I paint the shore, using a mix of TRIO and Payne's gray in the shadow areas and a mix of TRIO and titanium white for highlight areas.

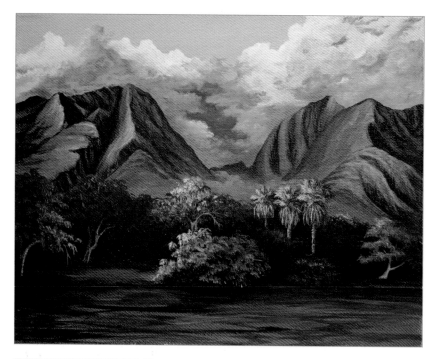

Step 5 Next I paint the palm trees one at a time, starting with the farthest tree. I mix three values of TRIO, cadmium yellow, and titanium white to paint the palm tree trunk and dry palm fronds, working back and forth with the three values to create the shape of the fronds. Then I paint the green palm fronds with a mix of sap green and Payne's gray. I add highlights with a mix of sap green and cadmium yellow. I repeat this process for the other two trees. I also add a little more detail in the mountains.

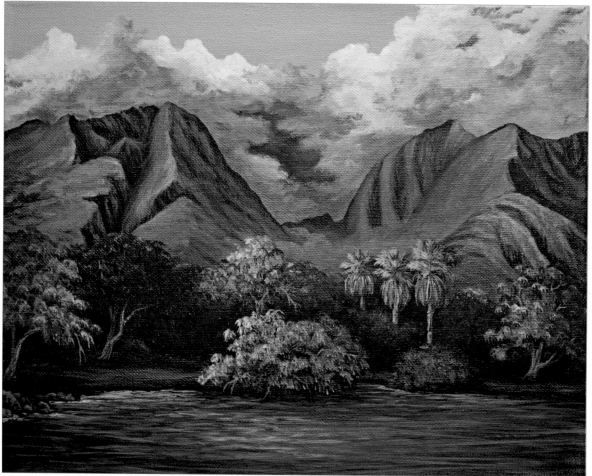

Step 6 I mix three values for the water. For the dark water, I mix phthalo blue, sap green, and a touch of Payne's gray. For the lighter water, I mix phthalo blue, sap green, and titanium white. I also mix a pink value for the sky reflections in the water. With a wash brush, I block in the water with long fluid strokes, alternating the three color mixes until the entire area is covered. Keep the paint thin and creamy to allow the warm under-painting to show through. The left and right corners and the shoreline should be darker than the middle of the water. While the water dries, I start to add the rocks on the left using Payne's gray. You can add as many as you want in varying sizes. I mix a medium value by adding a touch of titanium white and TRIO to Payne's gray. I apply it with a round brush, experimenting with the shapes. I highlight the ones I want to stand out the most by adding more white to the mix.

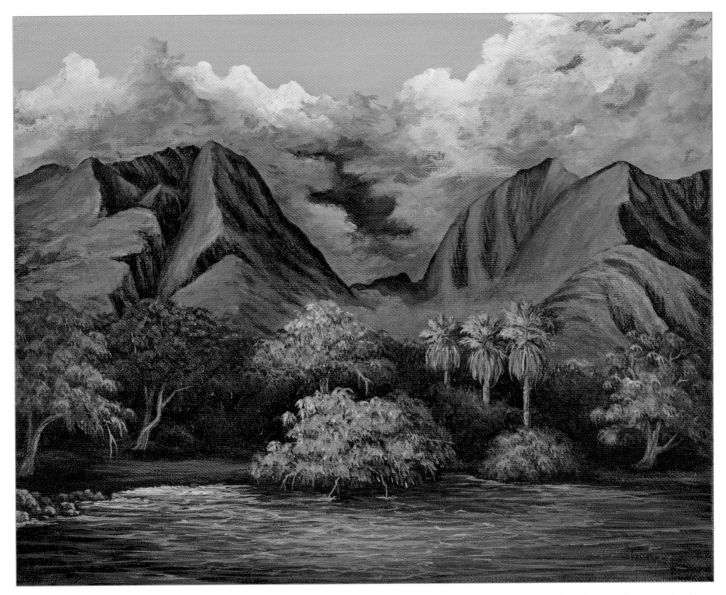

Step 7 Once I am satisfied with the rocks, I continue working on the water, adding details with a small round brush. I alternate between the three water mixes, using a combination of short, choppy strokes and long, flowing lines to create the feeling of moving water. I step back to take in the whole image from a short distance. Then I add some additional darks in the foliage. If you see an area that needs more work, go back and add to it. Once I am satisfied with the painting, I apply a varnish.

Twin Falls with Darice Machel McGuire

Twin Falls is the first waterfall on the famous road to Hana on the island of Maui. The day I visited, there wasn't a lot of water flowing, and the mossy cliff was pretty dry. I took lots of photos from every angle, including from behind the falls! The cave behind the falls was very damp and mossy, with trickles of water seeping through the rock. For this painting I used my imagination, as well as inspiration from behind the falls, to paint how I think they would look after the rainy season—lush and green.

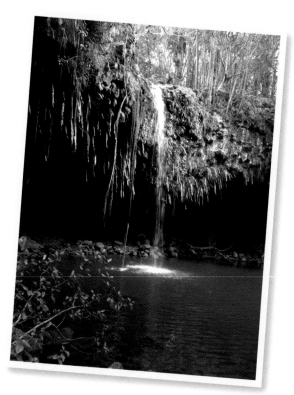

COLOR PALETTE

burnt sienna, burnt umber, cadmium yellow medium, Payne's gray, phthalo blue, phthalo green, titanium white

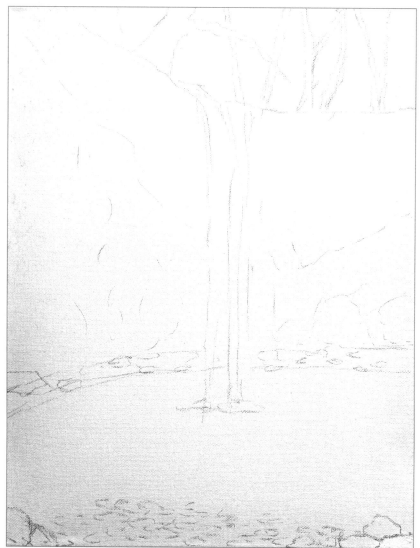

Step 1 I roughly sketch in the waterfall and loosely indicate where it flows. I also add a rough sketch of the trees and rocks.

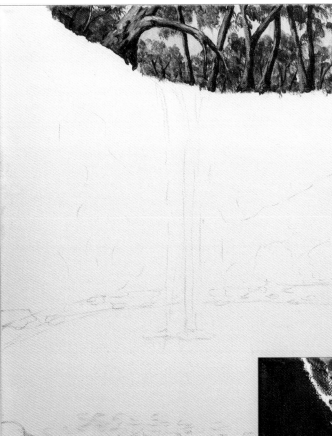

Step 2 I begin by painting the sky and trees. For the sky, I mix titanium white with a touch of phthalo blue and Payne's gray. I scrub the mix in with a large filbert brush, filling in the entire sky around the trees. Next I mix phthalo green, burnt umber, and cadmium yellow medium for the foliage. I dab in the leaves with a filbert brush, allowing pockets of sky to show through. I paint in the tree trunks, using burnt umber as the base color, burnt umber mixed with titanium white for the highlights, and burnt umber mixed with Payne's gray for the shadows. Feel free to detail the trunks as much as you wish.

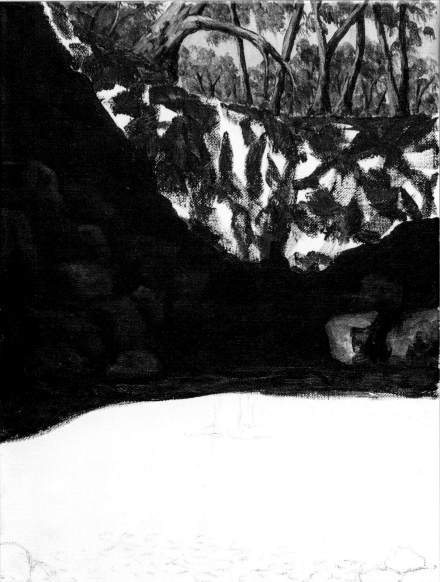

Step 3 Next I work on the cave behind the waterfall. For the darkest blacks, I mix Payne's gray with phthalo blue. I scrub in the dark mix with a wash brush, and I also use the color to block in shadows from the rocks on the cliff. Then I add a touch of titanium white and cadmium yellow medium to the mix and shape the large rocks in the cave using a large filbert brush. I mix burnt sienna, burnt umber, and Payne's gray and scrub in the floor of the cave with a filbert brush. Then I allow my painting to dry.

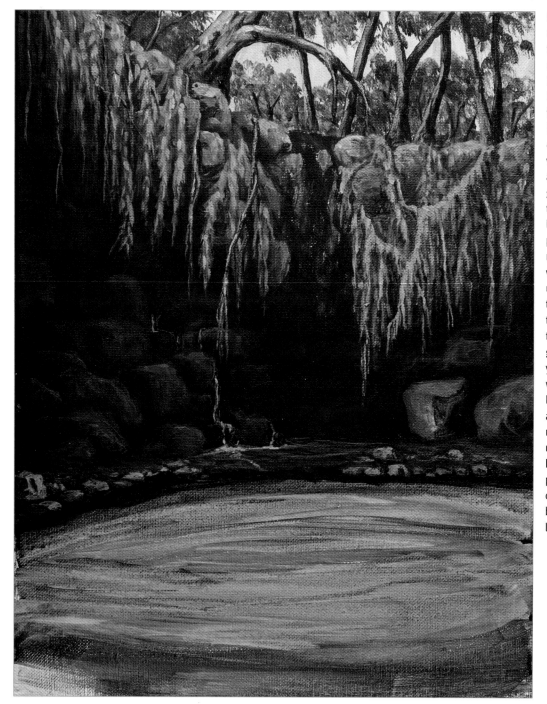

Step 4 I paint the rocks on the cliff face (see detail). Then I paint the waterfall underpainting with a very thin wash of Payne's gray. I paint the details of the mossy boulders and the cave's rock floor with layers of burnt umber, burnt sienna, Payne's gray, and combinations of phthalo green with cadmium yellow medium and phthalo blue with phthalo green. Allow each layer of paint to dry before building up a new layer. I use a round brush to paint the trickle of water with a mix of phthalo blue and titanium white. Then I paint the vines, using a mix of burnt sienna and titanium white. I add shadows to make the vines stand out. For the trailing moss, I mix phthalo green, burnt umber, and cadmium yellow medium and apply it with a small filbert brush. I add lots of cadmium yellow medium and titanium white to the moss mix for the highlights. For the underpainting of the pool, I mix burnt umber, phthalo blue, and phthalo green with lots of water to create a very thin mixture, which I brush in with a wash brush. Then I let the painting dry completely.

ROCK DETAIL

I mix burnt umber with titanium white and paint the base color of the rocks on the cliff face. For the shadows, I add Payne's gray to the mix. For the highlights, I add more white. For added warmth, I add a touch of burnt sienna and cadmium yellow medium.

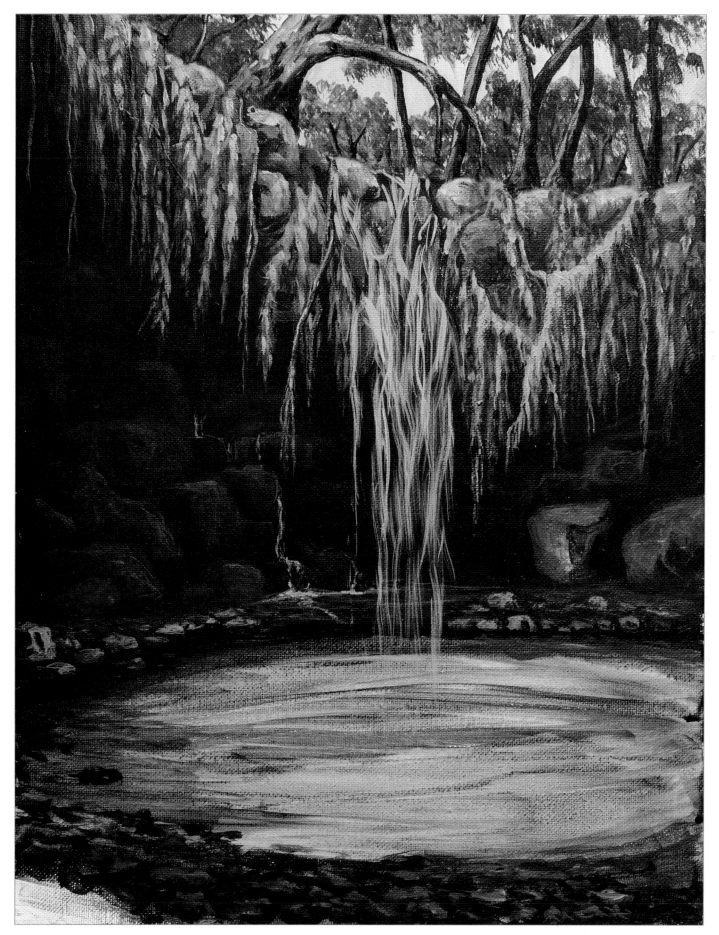

Step 5 Next I add an underpainting for the waterfall and foreground rocks. For the waterfall, I mix Payne's gray, phthalo blue, and titanium white. I add water to thin the paint and apply it with a filbert brush. I let the paint dry before adding shadow and shapes for the rocks with a small filbert brush, using the same color mixes as the cliff face in step 4. You don't need a lot of detail for these rocks because they will be underwater.

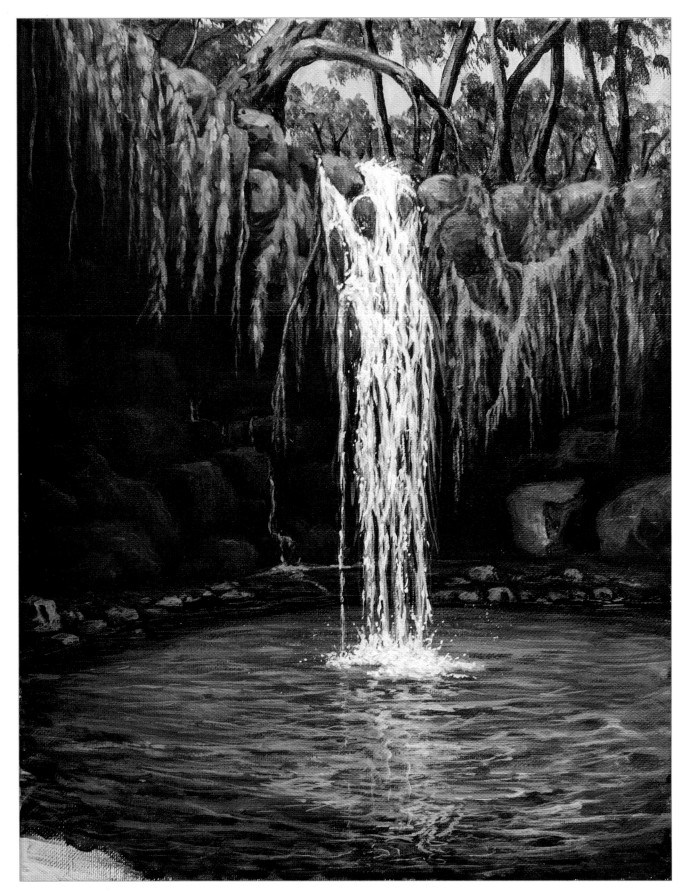

Step 6 I use a thin, transparent wash of phthalo blue, burnt sienna, and titanium white on the far left side of the pool and for the shadows of the ripples. For highlights on the ripples, I mix phthalo green with titanium white and use a small filbert brush. I add more titanium white to the water-fall underpainting mix from step 5 and scumble in the new color. I continue to build each layer by lightening the color and adding less water. The final layer is straight titanium white. I let the paint dry, and then I use a toothbrush to splatter thinned white paint for the tiny droplets of water. Don't forget to cover the areas you don't want to get spattered.

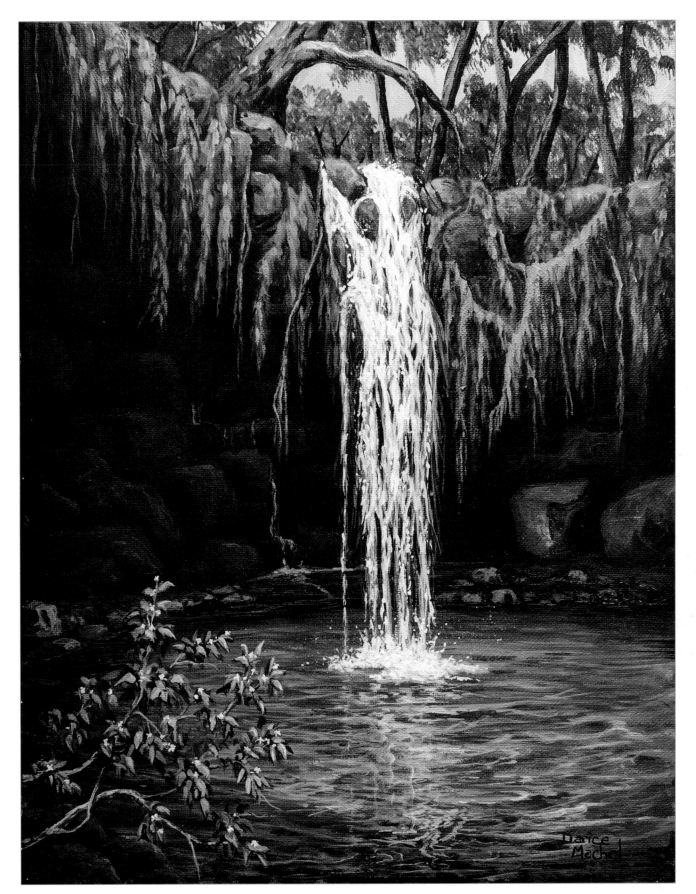

Step 7 I create the shapes of the boulders with Payne's gray. Then I add a medium value of moss green by mixing phthalo green, burnt sienna, and cadmium yellow medium. For the light moss, I add more yellow and use a small filbert brush to dab in the paint. Using a round brush, I paint the branches with a mix of burnt umber and titanium white, adding shadows and highlights as needed. I dab in the leaves with a mix of phthalo green and Payne's gray, adding cadmium yellow medium to the mix for the highlights. For the tiny flowers, I mix white with a touch of phthalo blue and apply crisscross shapes with a round brush. After viewing the painting from a short distance, I re-work the areas I'm not happy with and let the painting dry completely. Then I varnish it with a semi-gloss varnish.

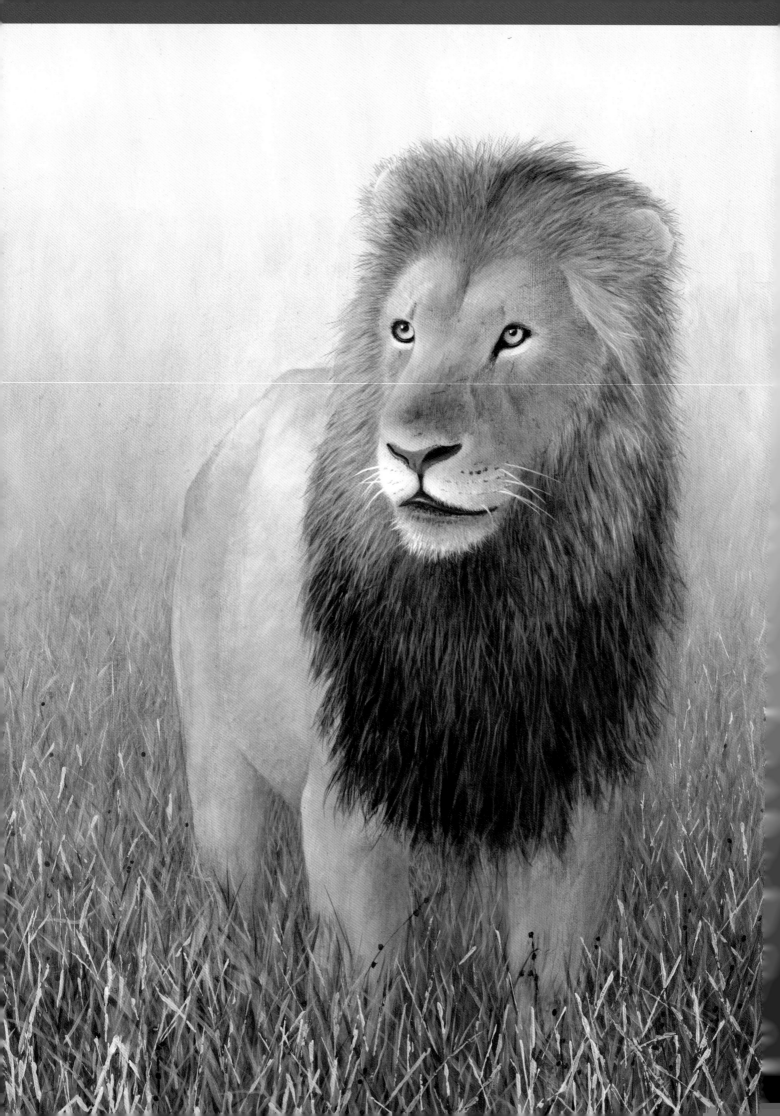

Animals

with Toni Watts

Capturing the beauty of majestic wildlife in a painting is a rewarding experience, and acrylic is a wonderful medium for creating realistic animal portraits. In this chapter, talented artist Toni Watts will help you discover how to paint gorgeous wild animals, beginning with a simple sketch and progressing to a finished, realistic portrait. Throughout the four step-by-step projects you will learn how to render fur, wrinkles, feathers, and reflection, as well as how to combine reference images for your ideal composition.

Painting Fur

At first glance, painting fur may seem like an insurmountable challenge. The key is to not try to paint each individual strand. Instead, look for patterns of light and dark, and use your brushstrokes to follow the direction of fur growth. You will be surprised at how easy it is to render realistic fur with just a few paint colors and some simple strokes.

COLOR PALETTE

burnt sienna, burnt umber, permanent alizarin crimson, raw sienna, raw umber, titanium white, ultramarine blue, yellow ochre

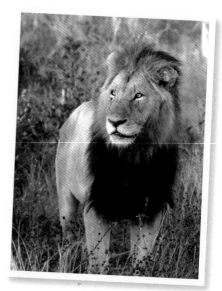

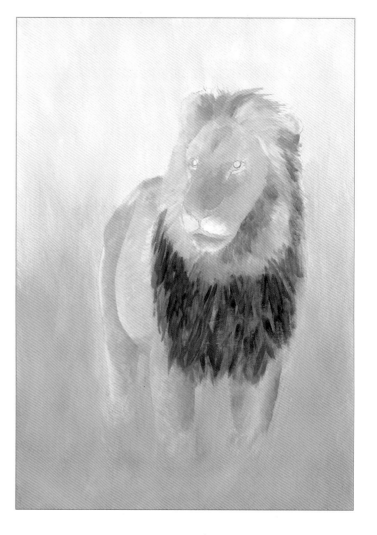

Step 1 I sketch out the lion before I begin painting. This helps ensure that I have plenty of room for the whole cat—including the feet! You can freehand your sketch or use tracing paper to transfer the main lines of the photo to your canvas.

Step 2 Next I block in the main shapes. I use a mixture of yellow ochre and titanium white and a 1" flat brush to block in the background. Keep your brushstrokes loose and vertical, mimicking grass. I roughly block in the lion with a mixture of raw umber and titanium white. This is a good time to identify the direction of light, reproducing the lighter and darker areas on the body in your painting. Getting these cues right at this stage will make the lion look believably three-dimensional.

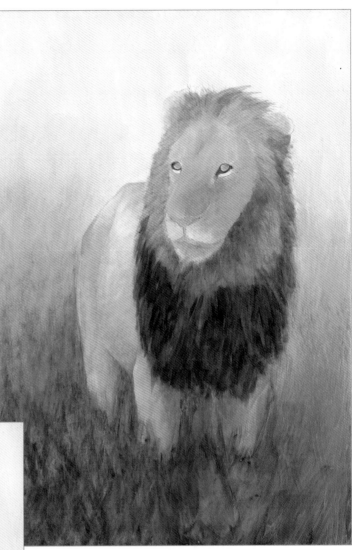

Step 3 I start to add color to the underpainting by applying diluted washes of raw sienna and burnt sienna over the lion's body and burnt sienna and burnt umber on the dark parts of the mane. I also scrub a mixture of burnt umber and ultramarine blue in the foreground. Although this looks quite dark, it will eventually form the background for the grass.

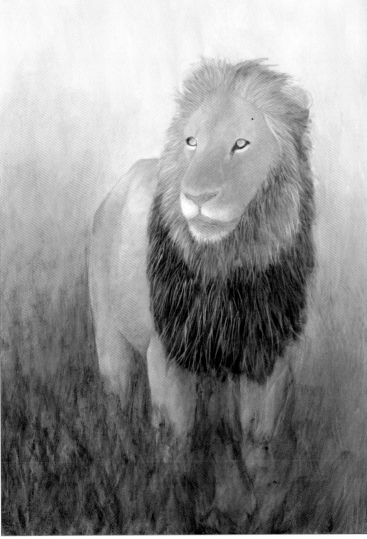

Step 4 Using a #2 brush, I add hairs to the face and mane with a mixture of raw sienna and titanium white. This paint is opaque and covers the darker colors underneath. I add random areas of dark paint—a mixture of ultramarine blue and burnt umber—between some of the mane hairs on the right. When the paint is dry, I wash diluted raw sienna over the lighter areas of the mane and a mixture of burnt sienna and burnt umber over the darker areas. I also lighten the parts of the eyes opposite the light source.

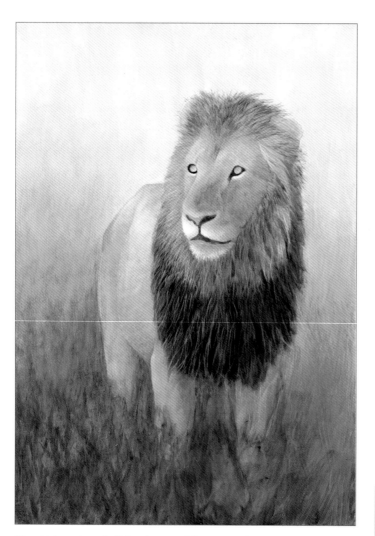

Step 5 I continue building layers of the mane. There are no shortcuts for this process! I add hairs in titanium white with raw sienna, and then I glaze over them with burnt sienna, burnt umber, and either ultramarine blue or raw sienna, depending on the part of the mane. I continue adding layers until the mane looks thick. I pick out the white hairs on the muzzle and put a diluted coat of ultramarine blue over the side of the face and legs facing away from the light.

ARTIST'S TIP

You don't need to paint every hair on the body. The viewer will automatically believe the individual hairs are there if the colors and the direction of the larger brushstrokes are correct. This saves you lots of time!

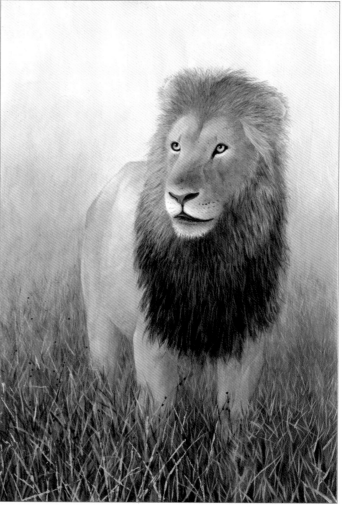

Step 6 I paint the nose with a mixture of alizarin crimson, burnt umber and titanium white. Then I start building up the grass. I use a mixture of titanium white and raw sienna for the first stems of grass on the right. I make the strokes thicker and longer in the foreground and lighter and shorter as they recede into the background—try smudging them with your thumb as they fade. I add some foreground stems with the edge of a palette knife to give texture and add interest. The stems don't need to be perfect; just aim for an impression.

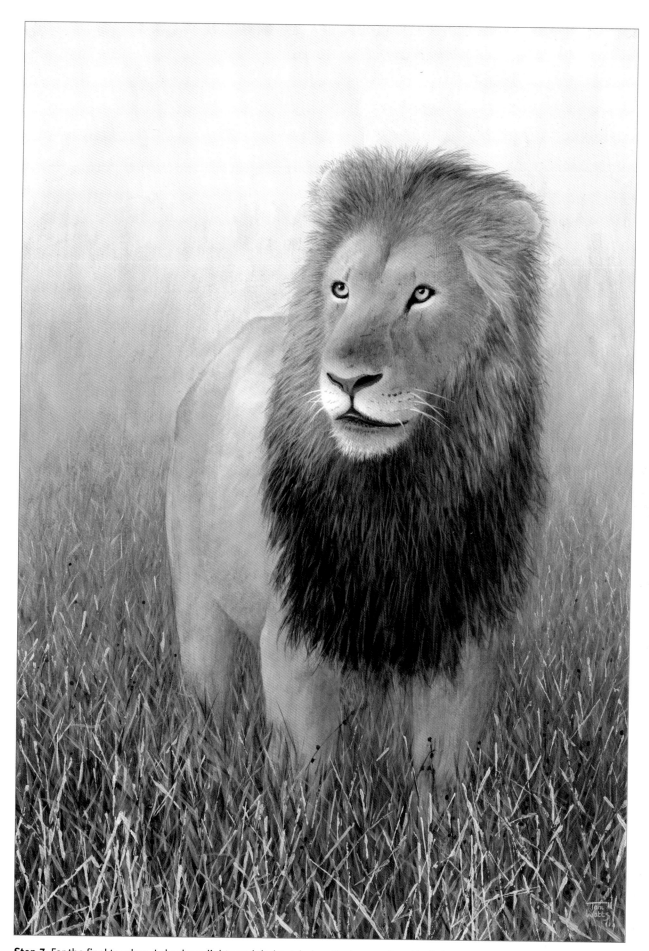

Step 7 For the final touches, I check my lights and darks. I darken the legs on the side facing away from the light, as well as the top right side of the mane. Then I check that the grass is believable, adding extra stems as needed. I also enhance the white catchlights on the lip and in both eyes, and I add white whiskers with a #000 brush.

Creating Texture

Thick, rough elephant skin is the perfect model for learning how to paint wrinkly texture. Learning to perfect this technique may take a little time, so practice on another canvas until you feel comfortable with the process—and don't give up if your first few attempts are unsatisfactory.

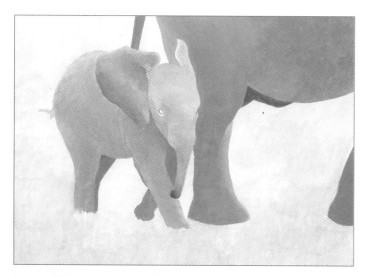

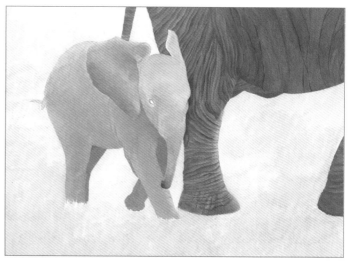

Step 1 I use a grid to make drawing the sketch freehand easier. I make the painting the same proportions as the photo and draw a grid on each, splitting the image into sixteen identical rectangles. It is much easier to copy the contents of a single segment than to manage the whole image at once.

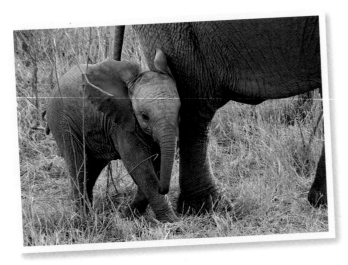

Step 2 Using a large brush, I block in the background with a mixture of yellow ochre and titanium white. I paint the elephants with a mixture of titanium white, raw umber, and a touch of ultramarine blue, which makes a warm gray. The only areas the sun falls on are the front of the legs and the side of the trunk, but there are subtle lights and darks within the image, which help make the elephants look three-dimensional.

Step 3 I work on the most deeply wrinkled area first—Mom's back leg. This is an exercise in blending and requires speed. I premix a light and dark gray, using the same colors as in step 2. Then I look for the major wrinkle lines and paint each fold of skin with a #1 brush, using one gray first and then immediately laying down the second so that it slightly overlaps. I quickly brush between the two grays to blend the colors. Make sure the light area at the top of the wrinkle fades into the dark area where the skin is deeper. The wrinkles on the rest of the body are less deep, so I use less variation between the light and dark paint.

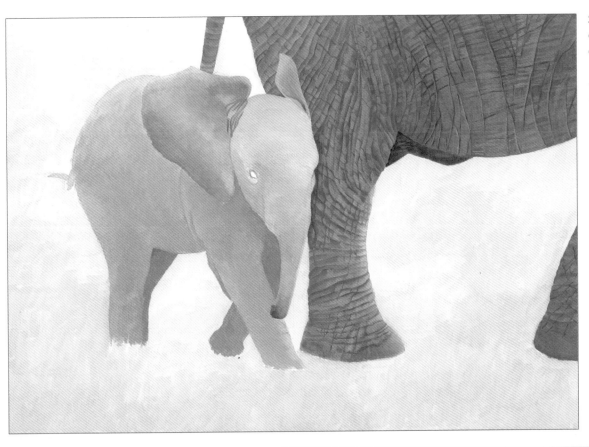

Step 4 Elephant skin doesn't wrinkle in just one direction. In some places, it almost has a checkerboard appearance. I look for wrinkle lines that cross the ones I painted in step 3 and add further shades of the same warm gray to mimic the texture. You can see that the shade of gray doesn't exactly match throughout. The variation in bluish-gray and brownish-gray adds interest to what would otherwise be a block of rather boring gray.

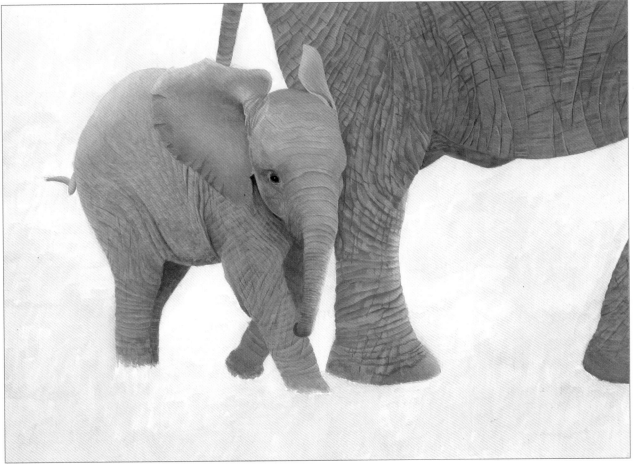

Step 5 I paint the young elephant in exactly the same way, but the wrinkles are closer together and less deep, so I don't use quite as much variation.

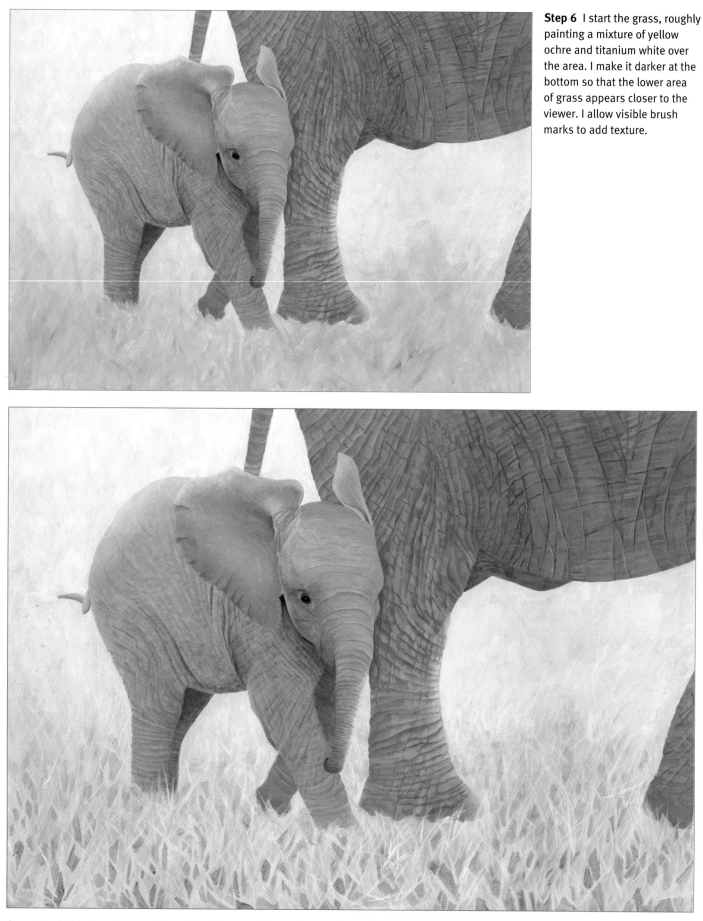

Step 6 I start the grass, roughly painting a mixture of yellow ochre and titanium white over the area. I make it darker at the bottom so that the lower area of grass appears closer to the viewer. I allow visible brush marks to add texture.

Step 7 I add blades of grass with a pale mixture and then paint a random selection of spaces between the blades with a mixture of burnt umber and ultramarine blue. I don't worry about making this neat, as most of it will be hidden by successive coats of paint.

Paint blades of grass from the base to the tip, easing the pressure on the brush as you go. This leads to a nice, natural point on each blade. It may help to turn your canvas or paper. I usually paint grass with the canvas upside down.

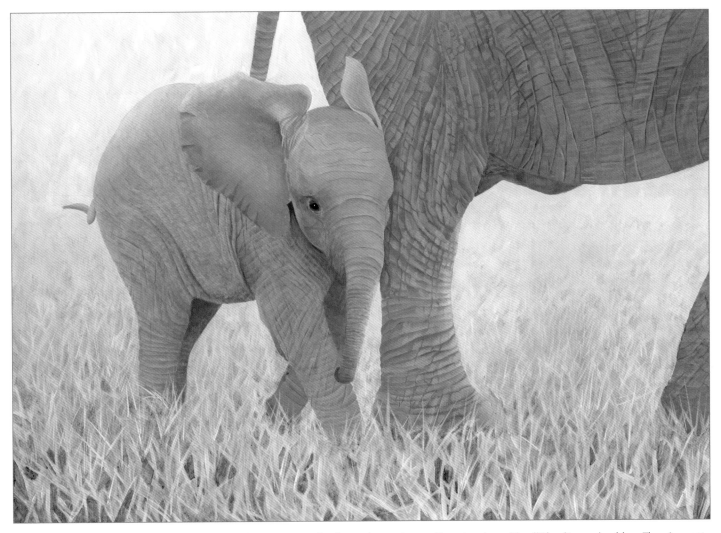

Step 8 I paint two diluted washes of paint over the grass, one of yellow ochre and one of burnt umber with a little ultramarine blue. Then I repeat step 7, painting more blades of grass and more areas between.

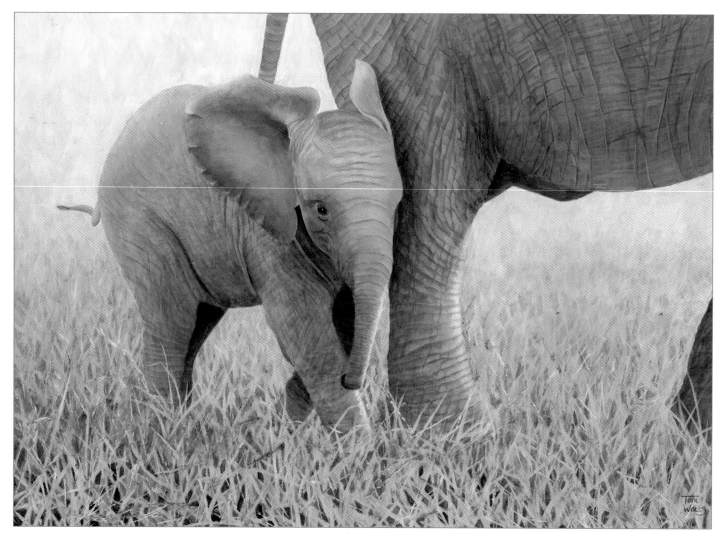

Step 9 Once again, I repeat step 7 to complete the grass. Then I add some blades of grass with the edge of a palette knife to create texture. I paint a diluted wash of yellow ochre over the whole grassy area. I spend some time darkening the darks and lightening the lights, especially on the young elephant. I also add the brush on the end of his tail and use a light wash of ultramarine blue and burnt umber to add a shadow, which anchors the elephants in their environment.

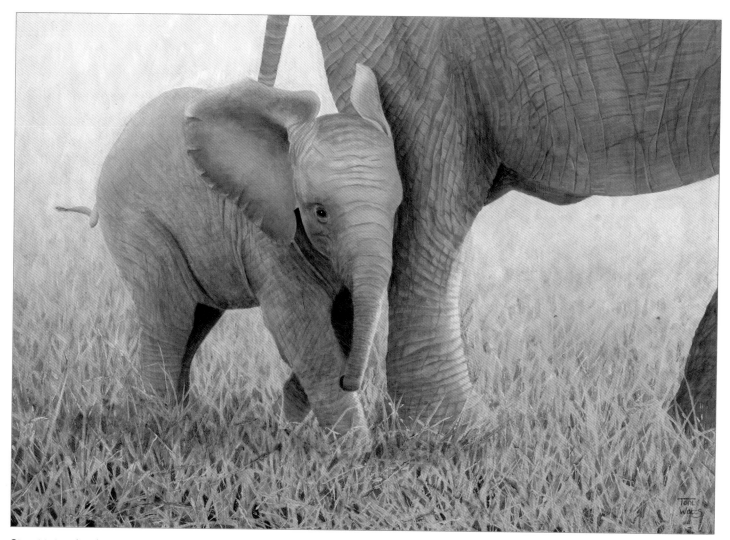

Step 10 I took a day away from my painting. When I looked at it again I decided that it didn't convey enough warmth—days in Africa are hot and sunny! I wash some diluted cadmium orange over the bottom half of the painting, deepen the shadows, and redefine some of the grasses, adding some extra blades with a palette knife. Now my painting is complete!

Taking Artistic License

In this project let's step away from the majestic creatures of Africa and focus on something a bit smaller. Instead of painting all of the out-of-focus background trees, I'm going to simplify this squirrel's surroundings so that the focus is all on him.

COLOR PALETTE

burnt sienna, burnt umber, cadmium yellow deep, Hooker's green, permanent alizarin crimson, permanent sap green, raw umber, ultramarine blue, titanium white

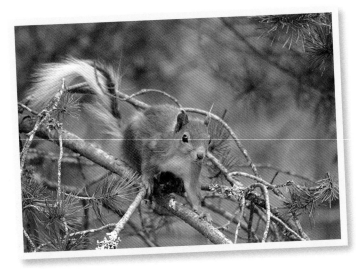

▶ **Step 1** I sketch the squirrel onto my support. I don't try to draw all of the small branches, partly because I will simplify them in the final painting and partly because painting the background would be difficult with lots of lines to paint around.

Step 2 I mix two natural-looking greens on my palette: (1) Hooker's green, titanium white, and burnt umber and (2) permanent sap green, titanium white, and burnt sienna. I also mix a little burnt umber and titanium white for the branch. Using a large flat brush, I paint the background quickly, dipping into either pool of green paint at random and blending as I go. I add more of any of the colors if I start to run low, which produces a wide variation of both color and tone. I leave some paler areas to give an impression of light and distance. While the paint is wet, I sketchily brush some of the burnt umber mixture in to give the impression of distant branches, avoiding defined edges. Then I paint the foreground branch.

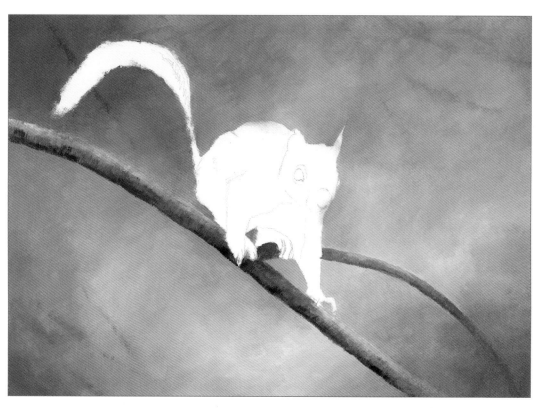

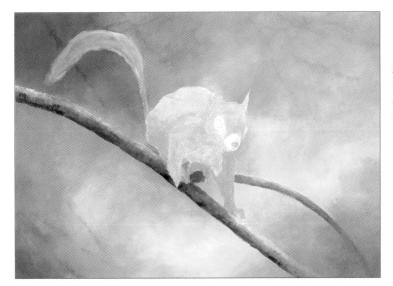

Step 3 I block in the squirrel with a mixture of raw umber and titanium white, looking for lighter and darker areas and adjusting the amount of raw umber in the mixture accordingly.

Step 4 Next I paint the first layer of hair with a reddish mix of burnt sienna and titanium white. For the paler hairs on the chest and tail, I use pure titanium white. Pay attention to the direction in which the hairs grow so that the squirrel looks natural.

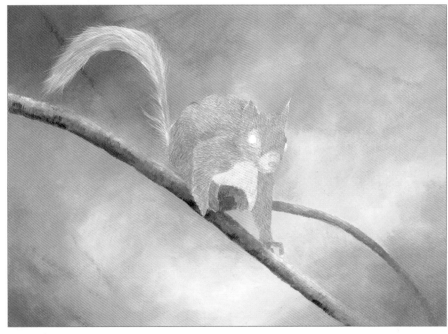

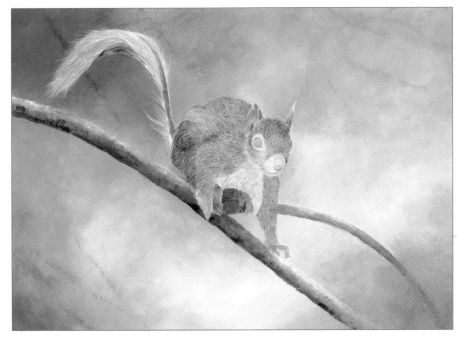

Step 5 Time to add more hair. At this stage, I carefully study the lights and darks, adding paler hairs with a mixture of titanium white and a touch of burnt sienna, and darker hairs with a mixture of ultramarine blue and burnt umber.

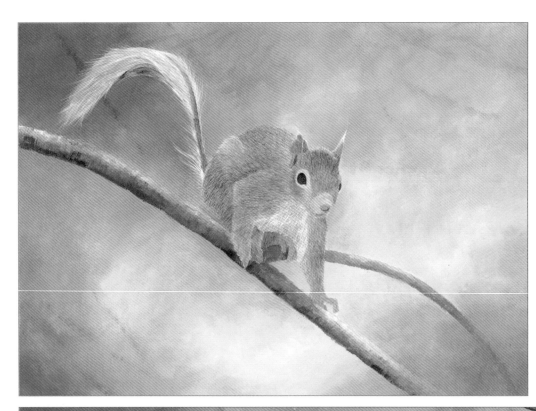

Step 6 I glaze the reddish areas of the squirrel with a diluted mixture of burnt sienna and cadmium yellow deep. I mix burnt umber and ultramarine blue to create a realistic black, and I paint the eyes. Then I add just a hint of alizarin crimson to the nose.

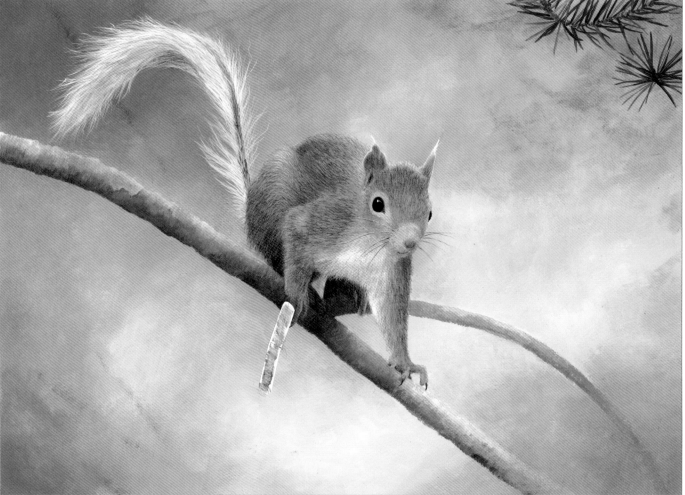

Step 7 I apply another glaze of burnt sienna, as well as extra touches to the fur and more tail hairs. I also add a catchlight in the eye to make the squirrel come alive. Then I begin to paint the branches. I freehand the green leaves at top right with a mixture of Hooker's green and burnt umber. I test the placement of a small branch with a piece of paper.

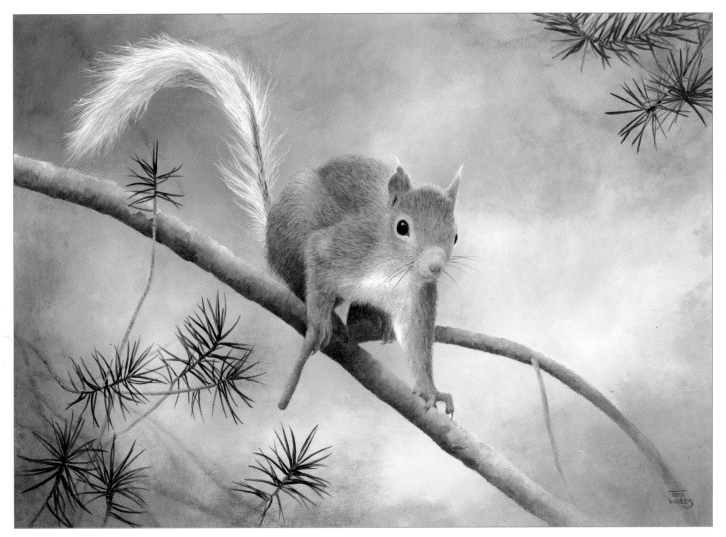

Step 8 I add more branches in the lower left corner to balance the painting. I wasn't sure where I wanted to put my branches, so I drew this section on a separate sheet of paper, roughly colored it in, and put it on the painting. I was able to look at it from a distance and have a better idea of the end result before I painted it. This is a great technique to use when you're unsure where to place something.

Painting Feathers & Reflections

This group of three northern lapwings (near right) makes a nice composition, but I decide to use an additional reference image (far right) to add a reflection to the closest bird. The beautiful iridescent quality of the lapwings' feathers can be challenging to capture, but in this project we'll walk through the process step by step.

Note: I painted this on a panel and, as I neared completion, decided to alter the size of the support (see step 9). Plan accordingly if you're following my project closely.

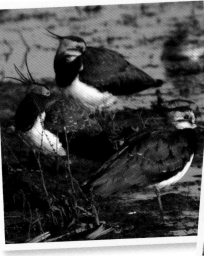

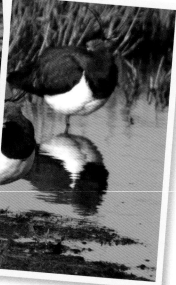

COLOR PALETTE

burnt sienna, burnt umber, Hooker's green, permanent alizarin crimson, permanent sap green, raw umber, titanium white, ultramarine blue, yellow ochre

Step 1 In my preliminary sketch, I overlap the two furthest birds (A), which automatically gives an impression of distance. In the photograph, the middle bird has one wing dropped forward. I didn't feel this would add to the composition, so I tuck the wing away (B). I leave some space between the foreground bird and the edge of the painting (C). I add a refection below the nearest bird (D) and use strands of seaweed to lead the eye in from the left (E).

Step 2 When I'm happy with the composition, I lightly sketch out the drawing on my support.

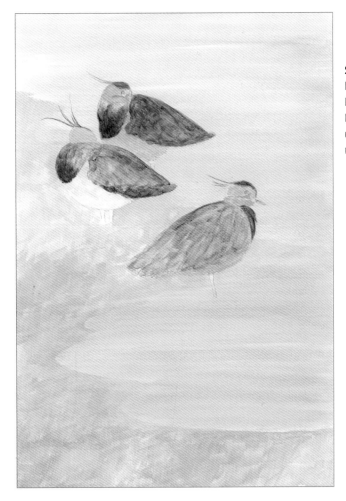

Step 3 I begin by blocking in the basic elements. For the water, I use a mix of ultramarine blue, burnt umber, and titanium white. For the land, I use a mixture of raw umber and titanium white. I paint the birds with Hooker's green. Then I use a mix of burnt umber and ultramarine blue for the dark feathers and a mix of raw umber and titanium white for the birds' faces and bellies.

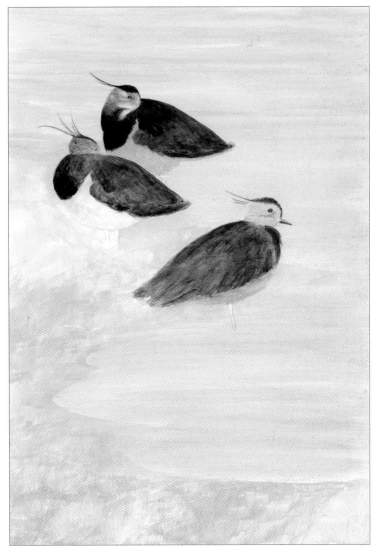

Step 4 Lapwings' feathers consist of a multitude of colors and an iridescent sheen. I try to mimic this by adding some burnt umber on each bird's shoulder and permanent sap green with just a touch of alizarin crimson across the rest of the upper body. I stroke on very diluted colors with a 1/4" flat brush. Then I use a #2 round brush to darken the birds' bibs with a combination of burnt umber and ultramarine blue.

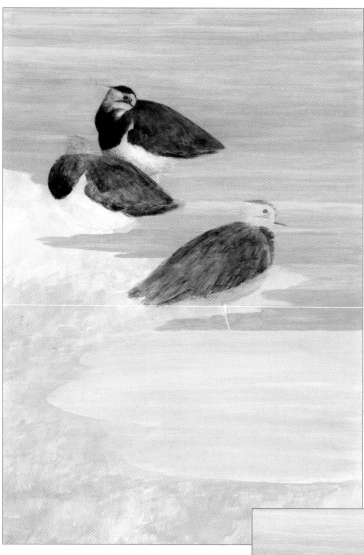

Step 5 Now that I've darkened the feathers, I can see that the water also needs to be substantially darkened. I build it up with horizontal strokes, using the same ultramarine blue, burnt umber, and titanium white mixture from step 3.

ARTIST'S TIP

The human eye sees less detail the farther away an object is. If you look closely, you can see that I use this fact to help create distance. The furthest bird has hardly any feather detail, while the bird in the foreground has quite distinct feathers.

Step 6 I paint more feathers, using the same colors as in step 4. I also begin adding dark areas on individual feathers of the foreground bird.

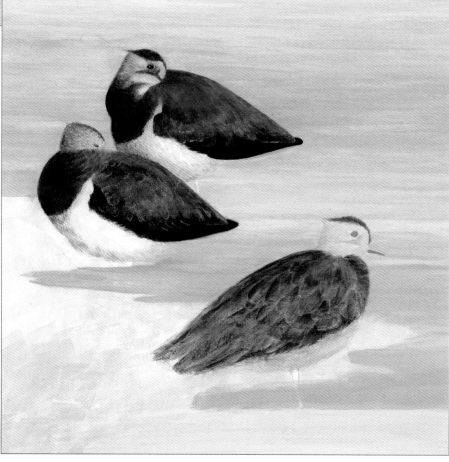

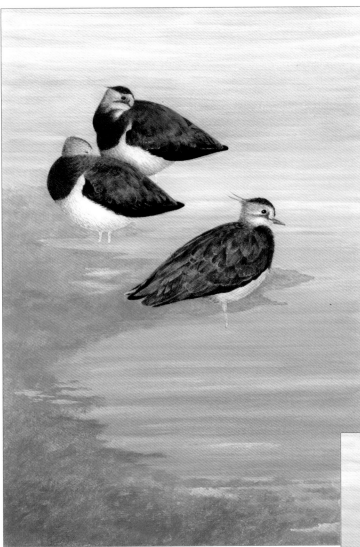

Step 7 Now that the greenish feathers are complete, I create the illusion of roundness by adding some burnt umber and ultramarine blue brushstrokes on the undersides of the bellies facing away from the light. I finish the water and then build up a rough shoreline with a mixture of burnt umber and titanium white.

Step 8 For the birds' reflections in the water, I use the same colors that I used to paint the birds, following the cues in my sample photo. All water is in motion to some degree, causing ripples that reflect at different angles. The peak of a ripple may reflect the sky, whereas the trough, in this case, reflects the bird's feathering. On a smooth surface, the reflected image will be almost a mirror image of the bird; in choppier water, the reflection will be distorted.

Step 9 As I study my painting, I decide that the bottom 3" do not add to the overall composition—it's just an extension of the brown shoreline. I decide to crop my support, focusing the attention of the viewer on the three birds. I work more on the reflection in the water, echoing the colors of the bird and making sure the marks are parallel. Take your time with this step. If the reflection lines are uneven, the water will look as if it is falling downhill!

Step 10 For the final touches, I add some broken winter grasses to the foreground and darken the bird's reflection in the water. I also darken the land with some burnt umber, adding small detail marks as I go, with just a touch of burnt sienna and yellow ochre in the foreground to make it appear closer to the viewer. Lastly I add the birds' crests to complete the painting.

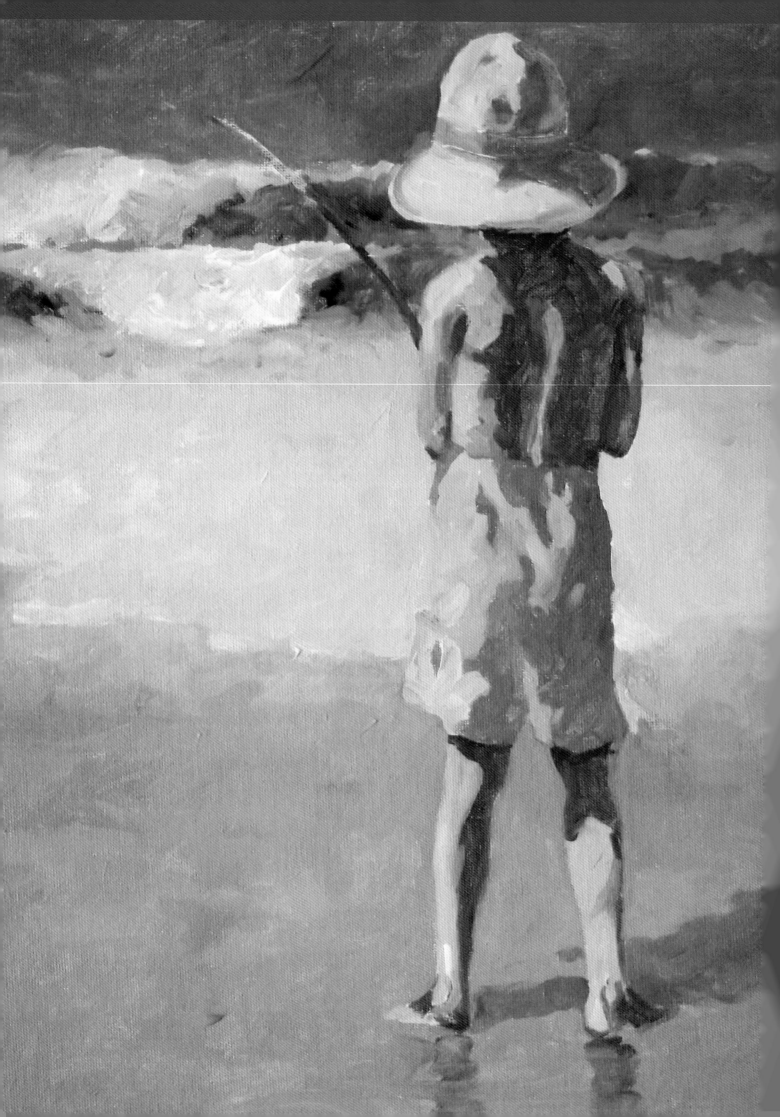

Figures & Portraits

with Michael Hallinan

No subject is more fascinating, illusive, or captivating than people. People come in all shapes, sizes, and colors—with an infinite variety and depth of personalities, stories, and characters. In this chapter you'll learn how to mix various skin tones, paint hair and other facial features, and create the illusion of roundness in limbs. Follow along with professional artist Michael Hallinan as he guides you through four easy-to-follow, step-by-step projects.

Studying Lights & Darks

I start every painting with a study of the pattern of lights and darks. I create a drawing, working from a black-and-white copy of a color photograph. Determining the lights and darks also determines the fundamental shape of the body. Anything that protrudes, such as a feature, muscle, or component of the skeletal system, will cast a shadow. The hollows of the body are also in shadow; for example, the spinal column is recessed between the long muscles of the back. This is a great beginning figure subject. There is no face or hands to worry about, so I can concentrate on the large shapes of light and shadow.

COLOR PALETTE

black, cadmium orange, cadmium yellow, raw sienna, titanium white, ultramarine blue

Step 1 I create a gray underpainting by mixing a very small amount of black paint with gesso and applying it to the canvas with a large brush. Once dry, I make a detailed drawing of the figure, mapping in the dark areas of shadow and leaving the white of the canvas for lighter areas. Getting the drawing right in this first stage will make the painting process much easier.

Step 2 I paint the shadowed side of the hat with a mixture of raw sienna and ultramarine blue. Near the edge, I add cadmium orange to create a warmer tone, which helps give the hat its round appearance. I use a mixture of cadmium yellow, raw sienna, and titanium white on the sunlit side of the hat, painting into the wet shadows to create a soft line. I use prism violet, ultramarine blue, and titanium white to paint the ribbon; these tones complement the yellows.

Step 3 The majority of the back is in shadow, and the boy is tan. I mix burnt sienna and cadmium yellow for a tan skin tone and paint the back. For shadow areas, I add a small amount of prism violet. Once again, I add cadmium orange as I near the edge of the body to create warm, reflected light. For the light areas, I mix burnt sienna, cadmium yellow, and titanium white. Paint quickly, and soften the lines by painting into the wet shadows.

Step 5 Next I paint the light tones in the shorts, using the same colors I used for the shadows, but with a lot more white. There are very few middle tones here, so I'm flooding the painting with sunlight color. The shadows cast on the legs follow each leg's shape, which creates an opportunity to reinforce the illusion that the legs are round. I paint with my same shadow skin tones from step 3, making sure that the shadows curve around the legs.

Step 4 I continue painting my way down the canvas, top to bottom and dark to light. Working this way is helpful so that if you have to rest your hand on the canvas for detail work there's no wet paint beneath. I combine earth tones, ultramarine blue, and titanium white for the khaki color of the shorts. I begin to block in the ocean with ultramarine blue and cobalt turquoise.

Step 6 Legs often get more sun than the rest of the body, so I adjust the colors as I finish the legs. I try not to introduce too many new colors as I finish a painting. For beginners especially, it's best to start with a limited palette and thoughtfully add new colors. In this step, I mix my skin tones, raw sienna, cadmium yellow, and burnt sienna for the sand. I add ultramarine blue where the sand is wet. For the ocean, I continue to use ultramarine blue and cobalt turquoise. I add titanium white to the mix to create foam on the waves. For the shallow foreground water, I use more white with blue to create the violet tone.

ARTIST'S TIP

As I paint, I leave color "notes" to myself about the colors I will use to resolve the background. For example, along the sunlit side of the pants, I created a color similar in value to the pants. This creates what is called a "lost edge." At some point, a portion of the figure must dissolve into the background; otherwise the figure will appear to be standing in front of the painting rather than in it.

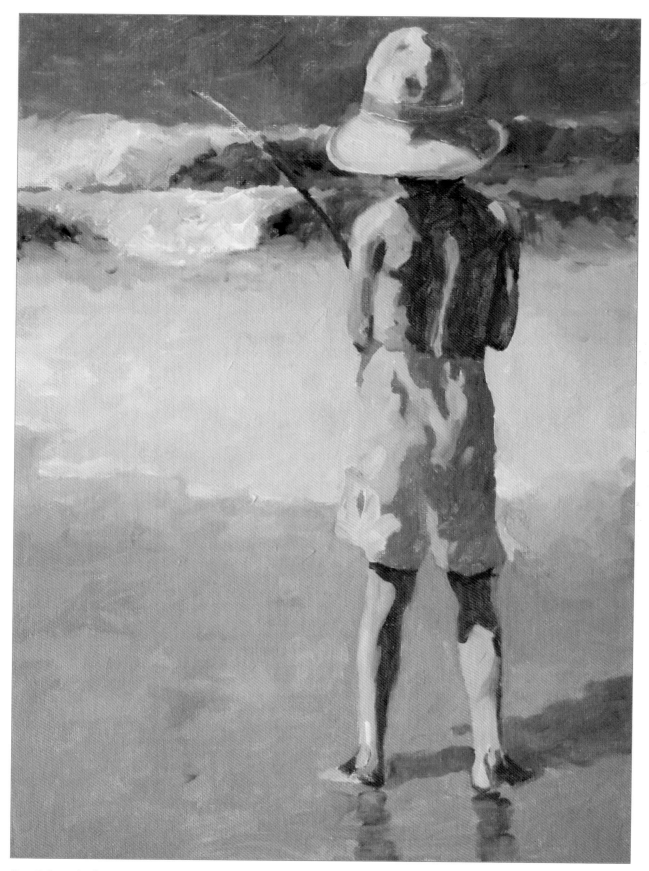

Step 7 Once the figure is complete, I finish the background based on the color notes I left myself. Try to keep the background simple. Its job is to support the figure, not compete with it. I add two waves to create some motion. Lastly, I add a shadow to ground the boy. Shadows are cool, so I always use ultramarine blue. For this shadow, I use a mix of burnt sienna and prism violet.

Painting Strangers

The less I know about a subject, the more time I spend drawing him or her. The drawing stage is where you get to know the face that you are going to paint. It doesn't take much to fail to achieve a likeness. Remember: a successful portrait is made up of a thousand small things done right. The good news is that any face can be reduced to a pattern of lights, darks, and middle tones.

COLOR PALETTE

alizarin crimson, burnt sienna, burnt umber, cadmium orange, cadmium red light, cadmium yellow light, prism violet, raw sienna, titanium white, ultramarine blue

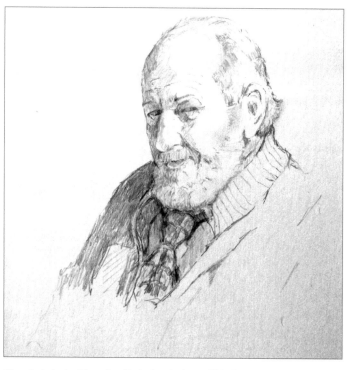

Step 1 I start with a detailed sketch that will help me get off to a good start when I start to lay down paint.

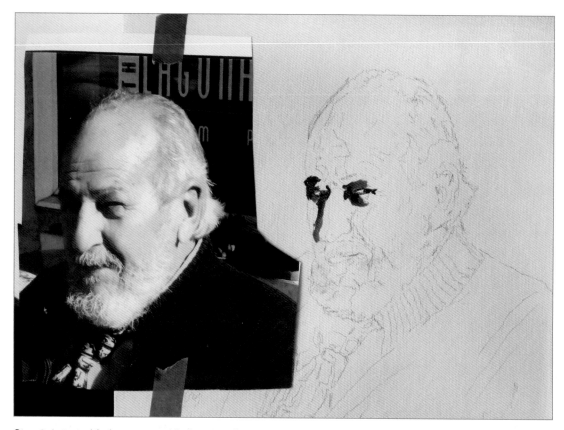

Step 2 I start with the eyes, as this feature tells more about a person than any other. The eyes and eye sockets are usually the darkest values on the face. I outline the eyes and fill in the pupil with a mix of burnt umber and ultramarine blue. I paint the shadows of the eye sockets with a mix of burnt sienna, raw sienna, and prism violet. If you want cooler shadows, add ultramarine blue to the mix. For warmer shadows, add cadmium orange. Notice how the eye shadows begin to define the upper edges of the nose. At this point, I'm not too concerned about getting the darks dark enough; it's much easier to return and darken them later than it is to rework an area that is too dark.

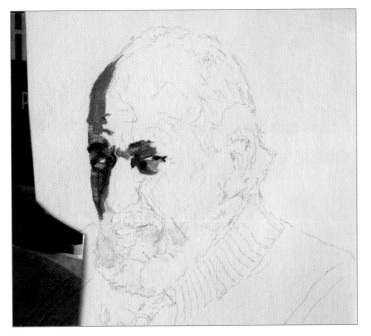

Step 3 Next I paint the shadows that define the curve of the skull. When I see blue in a shadow, I exaggerate it. This gives me an opportunity to expand my limited palette of skin tones. I mix ultramarine blue with prism violet and my midtone colors for this cool shadow tone.

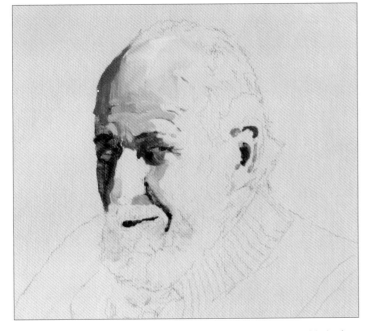

Step 4 Next I determine the actual skin tone, or *local color*. This is the color of the object in indirect light—not bright light or shadow. In this portrait I see the local color as a mix of burnt sienna, prism violet, and titanium white. I paint this color working out from the darks, which are still wet. I paint most of the face with this color, adding a little cadmium red light to the mixture in the cheeks and lips.

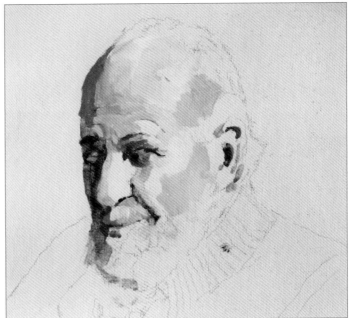

Step 5 I add some highlights to start bringing more dimension to the face. Highlights appear on the forehead, tip of the nose, and top of the cheek. You may have to squint at the photo to identify them; squinting eliminates the subtleties and allows you to see lights and darks without distractions. Highlights are typically cool, so I add a small amount of ultramarine blue or prism violet to titanium white. I paint the highlights into wet paint, which allows them to sit in the paint instead of on top of it, starting in the middle of the highlight and working out. I feather the highlight into the existing paint to avoid creating a hard edge.

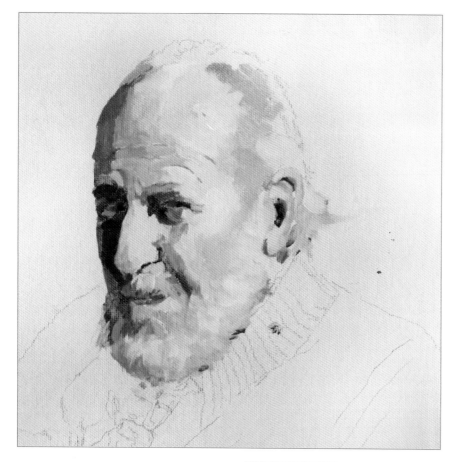

Step 6 The beard colors range from gray-white to pure white—and everything in between. As with most painting challenges, try to simplify the beard by dividing it into darks, middle tones, and lights. Hair color is dictated by skin tones, even white hair. I mix gray by adding a small amount of ultramarine blue and titanium white to my skin tone mixes. Mixing the color this way will make the beard look more natural. I start with the dark areas and add more titanium white to the mix as needed for the middle tones and lights. Remember to paint the beard into the face and the face into the beard. This technique will integrate the two and avoid a fake-beard appearance.

Step 7 I paint the hair in the same manner; however, you can see much of the scalp under the sparse hair. I start by painting a thin layer of my local skin color over the entire scalp. Then I use a mixture of titanium white, prism violet, and cadmium yellow light to paint the hair while the scalp is still wet. Don't try to paint one hair at a time. I like to use the drybrush technique with the side of the brush and work from dark to light. Pretend that you are sculpting, and follow the contour of the head with your brush. I paint the dark side of his sweater with alizarin crimson and ultramarine blue, which helps it merge tonally with the dark side of his face. For the tie and sweater not in shadow, I use alizarin crimson mixed with burnt sienna, adding a little titanium white as needed for lighter spots.

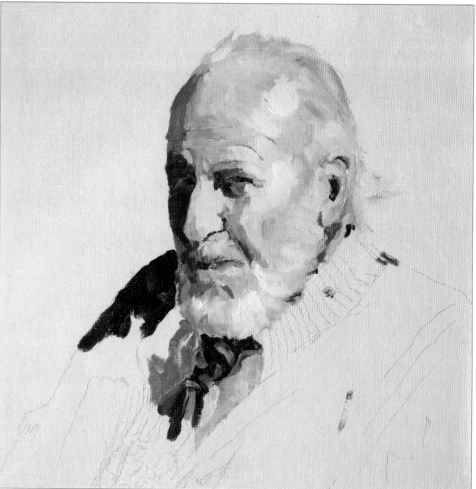

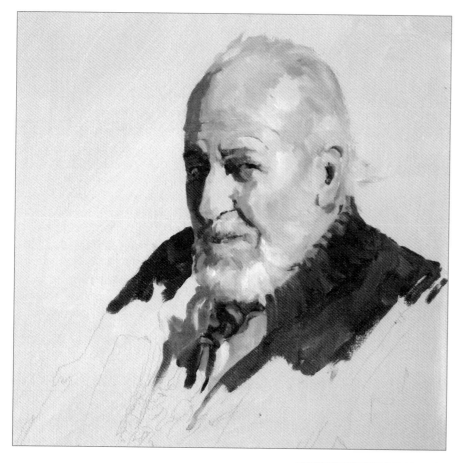

Step 8 The sweater is secondary to the portrait. I want to render it with minimal detail so that it supports the face rather than detracts from it. I keep painting with loose brushstrokes and begin to add the shirt as well.

Step 9 I paint more of the sweater, tie, and shirt as I work down the canvas. Then I start the background. I want to keep it simple so that it doesn't compete with the foreground. One way to achieve this is to use the dominant foreground color in the background mixes—in this case, the red of the sweater. I create a neutral background mix, using colors from the sweater and skin tones with titanium white in various amounts. I begin painting the background from the top of the canvas.

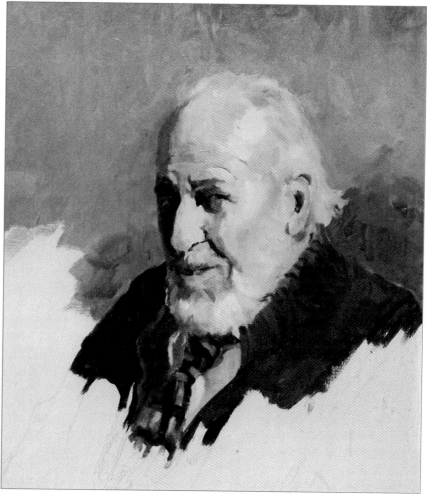

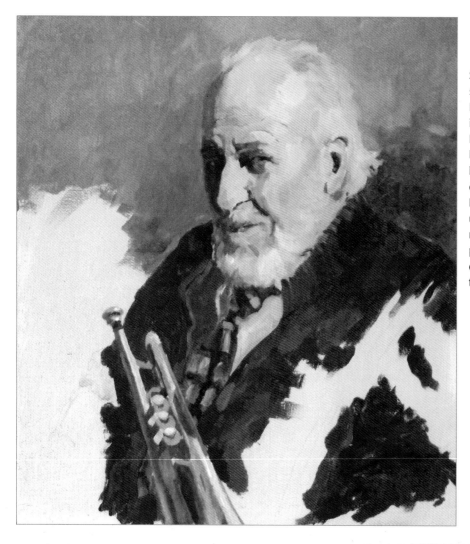

Step 10 I continue painting the clothing with simple strokes and applications of color. Then I add a trumpet to the hands. Like the clothing, this isn't the focal point of the portrait, so I keep the details to a minimum. Silver reflects light and can range from almost black to bluish-white. This trumpet reflects the alizarin crimson of the sweater. For the darkest value, I mix ultramarine blue with burnt umber. I mix ultramarine blue and titanium white for the middle values, and I add just a hint of blue to pure white for the highlights. I add cadmium orange along the reflective bottom of the trumpet.

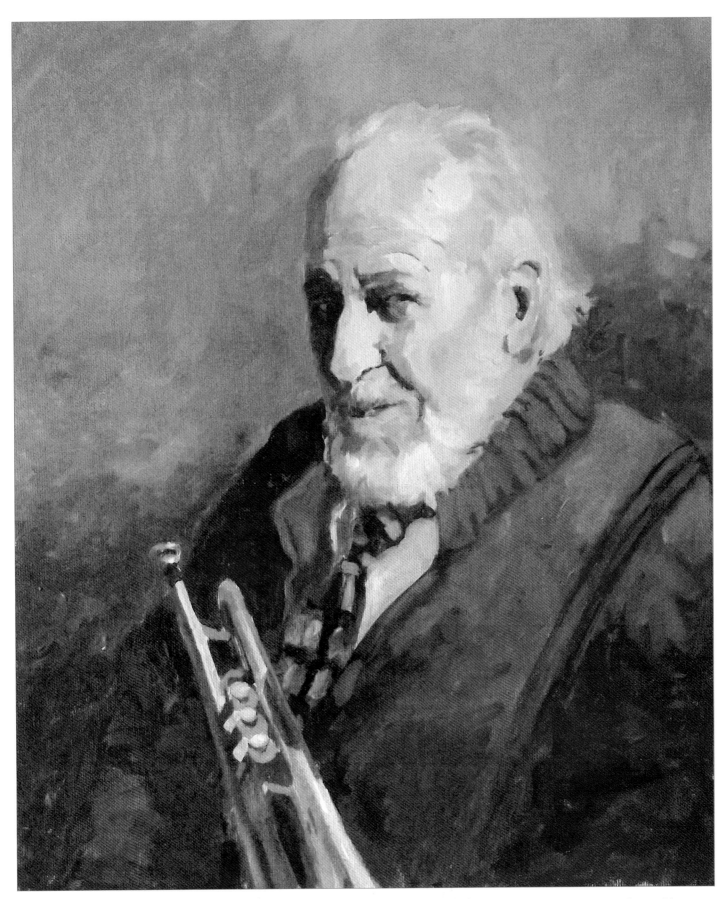

Step 11 I finish painting the rest of the clothing, trumpet, and background. Then I go over the whole painting looking for areas that could use some final details or tweaking. I like to finish a painting the following day. I put it on the wall in a frame and study it. Eventually, the painting tells me what it needs. Keep in mind that your first idea is usually right, so finish and rework your piece judiciously.

Maria

The range of human skin tones is almost impossible to grasp. They exist anywhere from light pink to blue-black, with every conceivable combination in between. I encourage you to study and practice creating as many tones as you can. Explore it all and revel in our diversity! In this project, I'll show you to how create darker skin tones and hair.

COLOR PALETTE

burnt sienna, burnt umber, cadmium orange, cadmium yellow, prism violet, titanium white, ultramarine blue

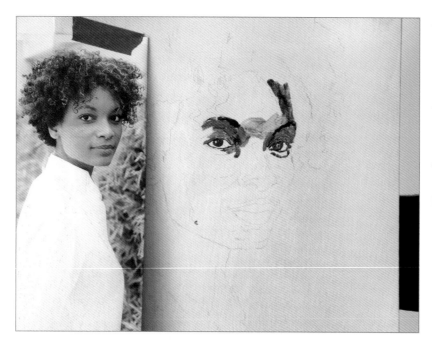

Step 1 After making my pencil sketch on the canvas, I start by identifying the dominant skin tone—the color that most defines the tone of the skin. In this portrait, I see burnt sienna as that color. I lighten it with cadmium yellow and titanium white and begin painting. Where darker shadows appear, I darken my mix with ultramarine blue. For the more muted tones, I gray down the tone by adding prism violet. Using one color, a *mother color*, ensures harmony throughout the portrait. I paint the eyes (including the brows and lids) with burnt umber and ultramarine blue. I mix ultramarine blue and prism violet into burnt sienna to paint the recessed eye sockets.

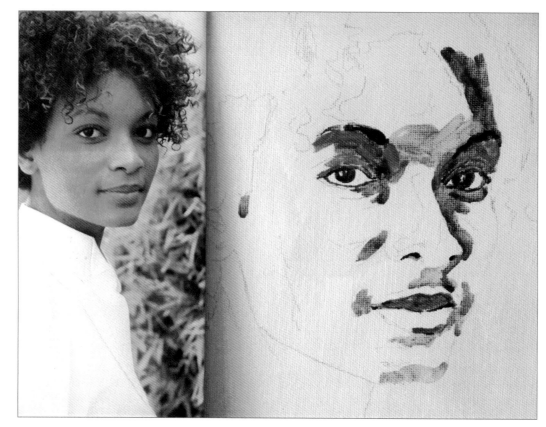

Step 2 I continue establishing the shadows, using burnt sienna as the mother color. As the shadows emerge, the face begins to define itself. I paint the dark areas to the right of the nose with burnt sienna and prism violet, with cadmium orange for reflected light on the edge of the cheek. I begin painting the lips, using the same skin colors to make them appear natural.

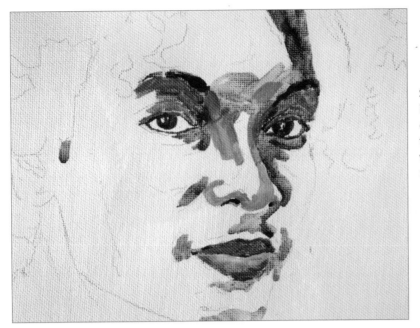

Step 3 I finish painting the lips. Note that the top lip is always darker than the bottom lip, but there is a cast shadow just under the bottom lip where it protrudes. I add a pure white highlight to the bottom lip while the paint is still wet. Then I start painting the nose with cadmium yellow mixed with burnt sienna.

Step 4 The chin's cast shadow on the neck defines the jawline. For this shadow I use a mix of burnt sienna, ultramarine blue, and cadmium orange. If you find your shadows are too muddy, add some orange to bring them back to life. I continue painting the rest of the face with my skin tone mixes. Then I start the hair. I use the drybrush technique to paint extremely curly hair, allowing the brush to sculpt the curls. I use a dark mix of burnt umber, burnt sienna, and ultramarine blue. Adding dark hair next to the face helps ensure that the skin tones have the right amount of contrast.

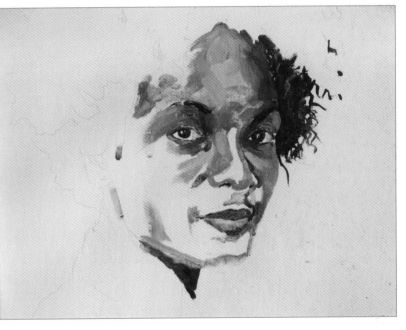

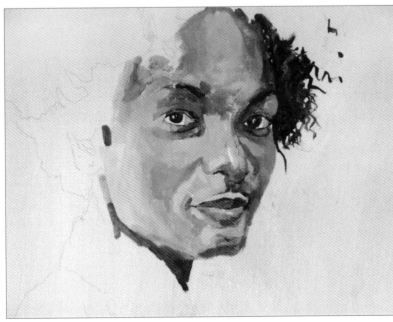

Step 5 I continue painting the rest of the face with my skin tone colors, blending the various mixes into one another for smooth transitions. Next I add highlights to the forehead, cheeks, and nose with prism violet, burnt sienna, and titanium white. Add a little ultramarine blue if the color is too warm.

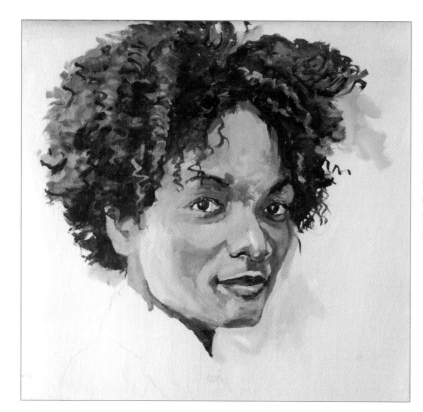

Step 6 I build out the rest of the curly hair, using the same mix from step 4. Study the reference photo and look for contrast. The hair is darker around the neck and significantly lighter at the crown of the head. I add some of my light skin tones to the hair mix to paint the lighter areas. Then I introduce the background color, cadmium yellow, to make sure it is compatible with the portrait. I use the background to correct any drawing errors I notice and to soften the chin.

ARTIST'S TIP

When painting a white object, look for the other colors that comprise the object and paint those first—in the case of the white blouse, those colors are yellow and blue-violet. You may be surprised by how little white there is!

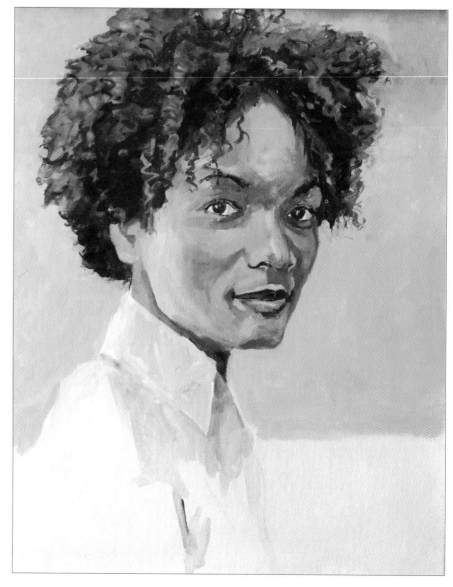

Step 7 I continue filling in the background, working the hair into it to integrate the painting. I begin the blouse, using my yellows, prism violet, and lots of titanium white.

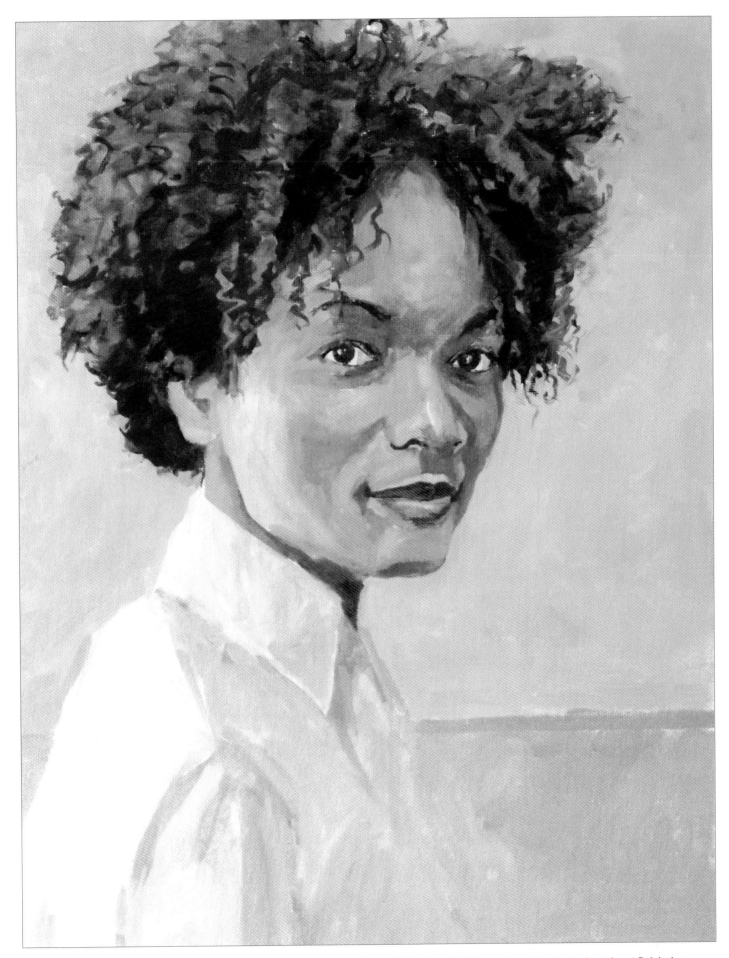

Step 8 I paint the bottom of the background a soft violet, using my shadow mix for the white blouse to create a lost edge. Then I finish the blouse, using the same colors as in step 7.

Painting Two Figures

When working on a painting of multiple people, I always develop one figure at a time. I try to work wet-into-wet as much as possible to keep the painting consistent and to create soft edges and transitions.

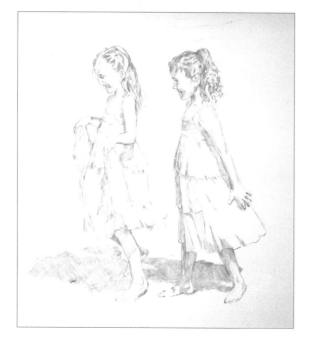

Step 1 I make a detailed pencil sketch on my canvas, paying careful attention to shadows and reducing the figures to a pattern of lights and darks.

ARTIST'S TIP

When painting multiple figures, you will often work from more than one photograph, and the scale of each photo may vary. Print several photos of each subject to ensure that you have the proper size relationship between subjects.

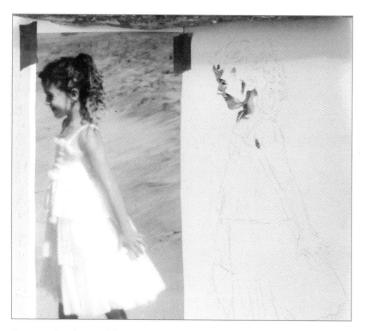

Step 2 I begin establishing the shadows in the face of the girl on the right with a watery mix of burnt sienna and prism violet. All faces are defined by shadows. Look for shadow pattern, and note any protruding features that catch light and cast shadows. Keep your dark mixes thin; you can always darken them later once you are satisfied with their likeness.

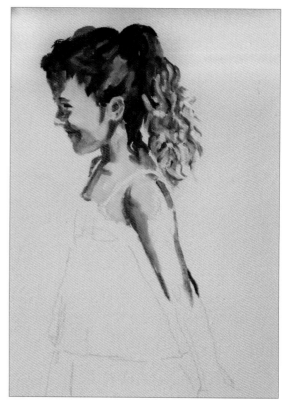

Step 3 I continue painting the chest and arm; then I paint the dark values in the hair with a mix of burnt umber and ultramarine blue. I add raw sienna and a bit of titanium white to create a middle value. I paint the highlight, which follows the scalp's curve, with a mix of ultramarine blue, burnt umber, and white.

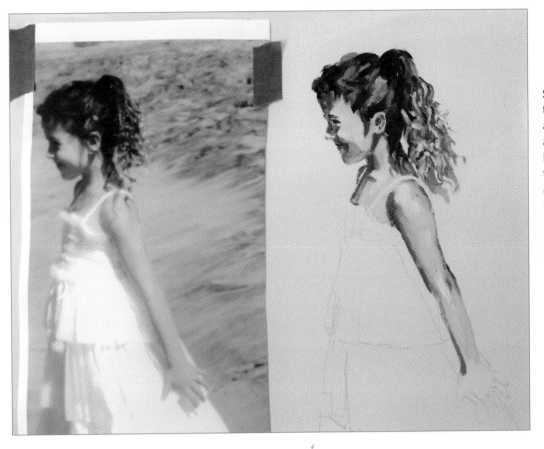

Step 4 I continue adding skin tones of burnt sienna, raw sienna, and cadmium yellow light to the arm. Note that there is a highlight on the shoulder socket at the highest point of the curve. I always add a little cadmium red light on elbows. To create the illusion of roundness on the forearm, I paint a light prism violet highlight along its length.

Step 5 It's important to develop the dress along with the skin tones—they work together. Like skin and hair, the dress consists of lights, darks, and middle tones. I try to keep it simple. I use ultramarine blue, prism violet, and a bit of titanium white to paint cool shadows. Reflected light is warmer than shadow and lighter in tone; I add more violet and white and less blue for these areas. When a scene is drenched in sunlight, I always add a bit of yellow, as white alone is icy.

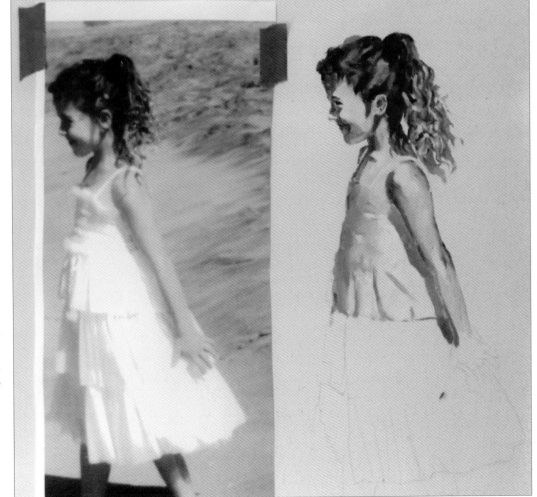

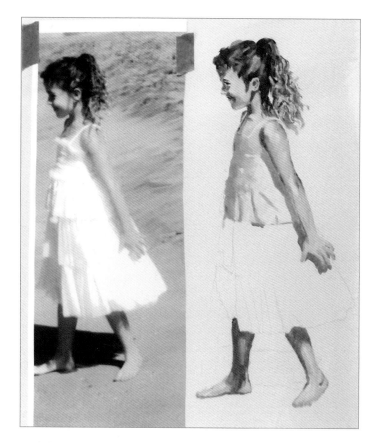

Step 6 I finish painting the arm, hand, and legs with the same palette I used for the rest of the skin. I add ultramarine blue to the mix for areas of shadow. Note that one leg is partially in shadow; I wrap the shadow mix around the leg to reinforce its roundness. Both the hands and feet have a pink tone, so I add a little cadmium red light and titanium white to my mix for these areas.

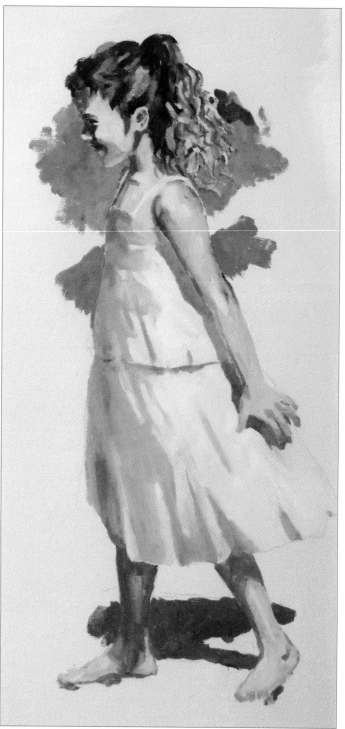

Step 7 I finish painting the bottom of the dress, using the same mixes from step 5. Next I anchor the figure to the ground with a shadow. I mix the shadow color with ultramarine blue, prism violet, and some of my skin-tone mixes. The earth-tone colors in the skin-tone mixes gray the shadow so that it harmonizes with the rest of the colors in the painting. Then I start the blue ocean background, using ultramarine blue and cobalt turquoise.

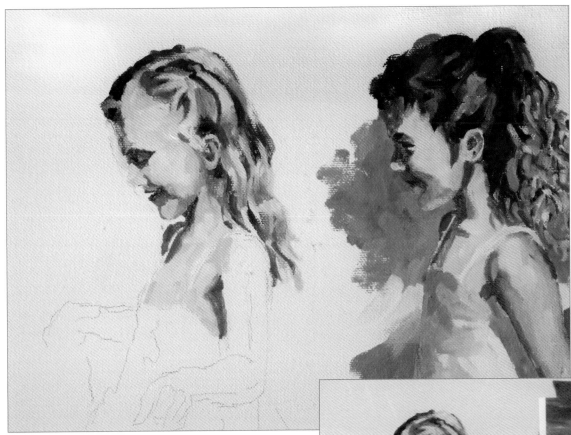

Step 8 I move on to the next figure, painting the face and chest with the same color palette as before. This girl has fairer skin, so I lighten the mixes some. For her blond hair, I use cadmium yellow light, raw sienna, and titanium white. I add burnt umber for the darkest shadows. If the hair is too yellow, add a little prism violet to tone it down.

Step 9 I finish painting the girl's arm and legs, using the same method as I did on the first figure. I use more cadmium red light along the back of her upper arm. Note that her legs are more in shadow. Then I begin the white dress by painting the darker values, using the same shadow mix from step 5.

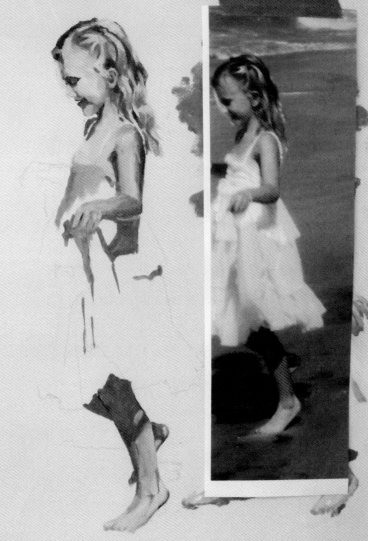

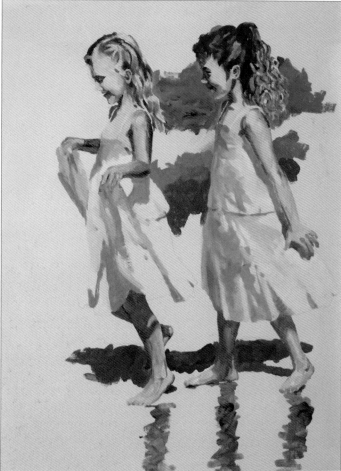

Step 10 I extend the shadow on the sand to ground the second figure, using the same mix from step 7. I begin to add more of the ocean, and I add the reflection of the girls' legs, using a mix of raw sienna, burnt sienna, and a touch of prism violet.

Step 11 I finish the ocean, using various mixes of ultramarine and cobalt turquoise for depth and variety. As the ocean comes forward, I add more titanium white until the mix is almost pure white. Then I add a bit of cadmium yellow light to add warmth. For the foamy water, I use a mix of titanium white with small bits of cadmium yellow light and ultramarine blue. A lost edge is created where the dress meets the surf, which helps integrate the figure into the surroundings. I paint the sand with a mix of raw sienna, prism violet, ultramarine blue, and burnt sienna, adding more prism violet or ultramarine blue for darker spots.

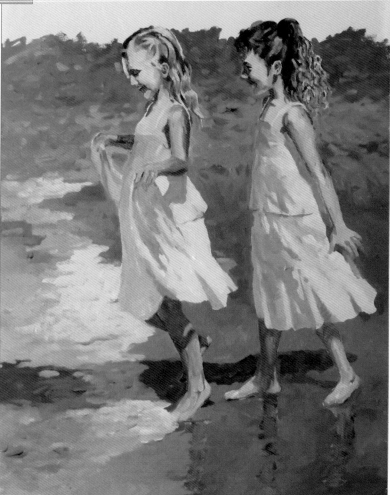

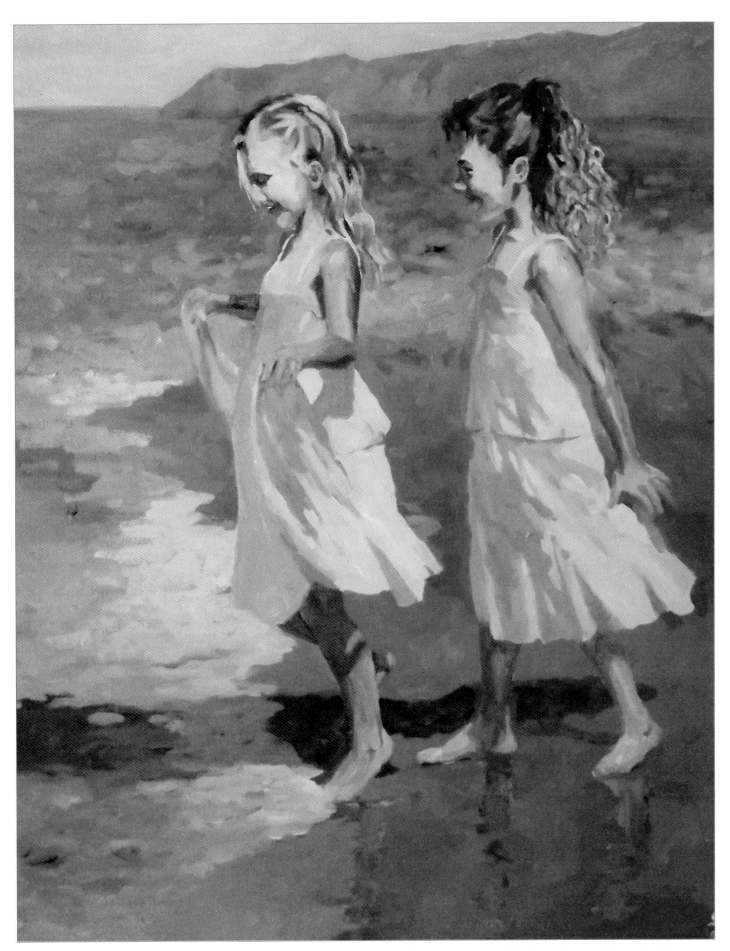

Step 12 I finish by adding the sky, using a combination of colors that occur elsewhere in the painting. The sky and water reflect each other, but the sky is lighter and warmer than the ocean. I use titanium white, prism violet, and cadmium yellow light to paint a sky that is accurate and harmonizes with the rest of the painting. I develop the distant land mass in the background with burnt sienna, ultramarine blue, prism violet, and titanium white, adding more white until the colors lose intensity and recede into the background.

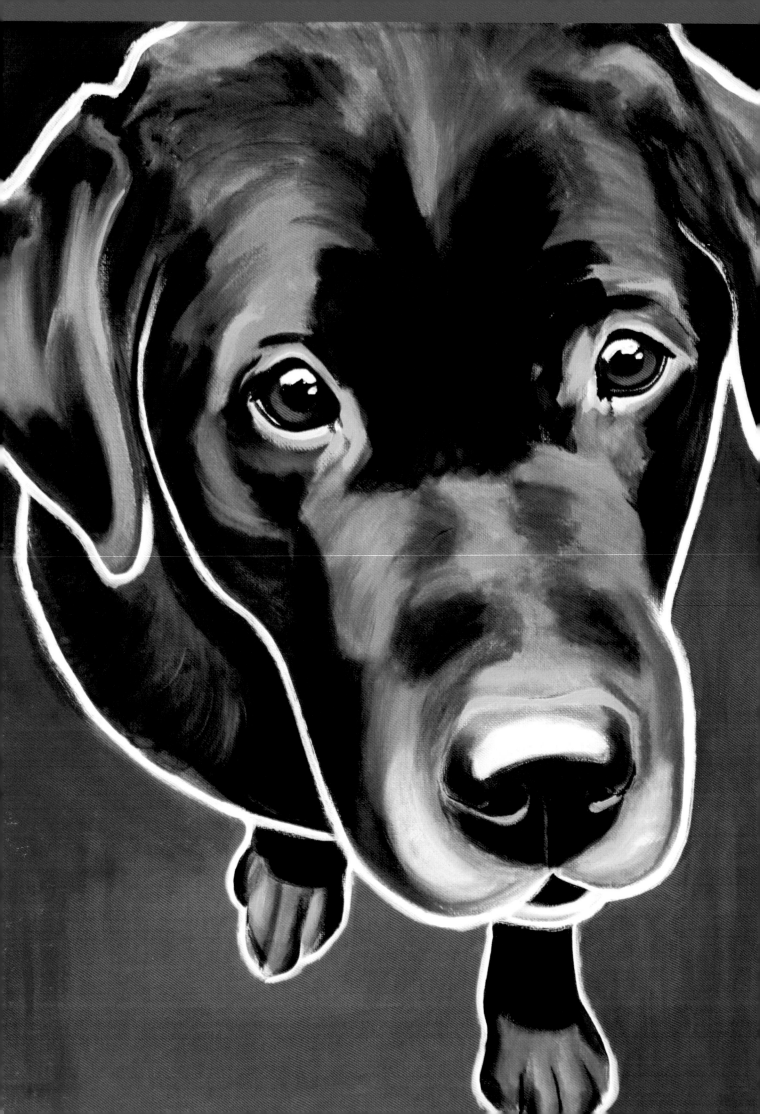

Pop-Art Animals

with Alicia VanNoy Call

The vibrancy of acrylics makes them a perfect choice for exploring and playing with color. Art doesn't always have to be traditional. As long as the values in your painting match the values in your reference photo, you can paint using any colors you wish. In this chapter, Alicia VanNoy Call introduces you to a style of painting that employs arbitrary color to bring out the colorful personalities of six animals, including dogs, an elephant, a giraffe, and a zebra.

Llewellin Setter

This lovely Llewellin setter is named Cheetah. The most compelling part of this reference photo is the light in her beautiful brown eyes. I also love her endearing smile. A photo like this is a joy to paint, as the soul of the animal shines through to inspire a wonderful painting.

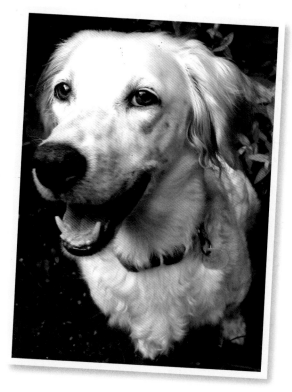

COLOR PALETTE

brilliant blue, burnt sienna, cadmium orange, cerulean blue, dioxazine purple, light blue, light magenta (quinacridone magenta + titanium white), light portrait pink (napthol crimson + cadmium orange + titanium white), powder blue (ultramarine blue + titanium white), quinacridone violet, titanium white

Step 1 I sketch directly onto the canvas. I may miss a few details, but since my style is loose, I'm more interested in capturing the spontaneity and energy of the subject, rather than every tiny detail.

ARTIST'S TIP

This is a *high-key* subject, which means the values are mostly light, so I'm going to have Cheetah stand out against a dark background.

Step 2 I block in the darkest darks with dioxazine purple. I never use pure black; purple creates a much warmer dark that is more vibrant. I thin the paint for the midvalue shadows by applying paint to the brush and then dipping it into water, making sure to catch any drips with a paper towel. For darker purples, I use straight paint on a lightly moistened brush.

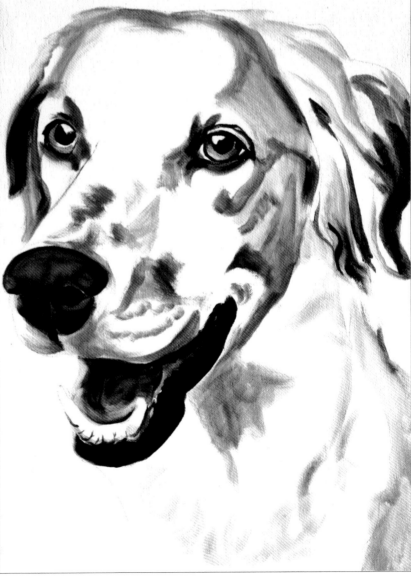

Step 3 I work on the next lightest darks with quinacridone violet. Cheetah's nose has some red tones, so I start there. I also lay in some reds in the tongue and in the orange spots on the ears and face. I lay in some value to start the irises of the beautiful brown eyes.

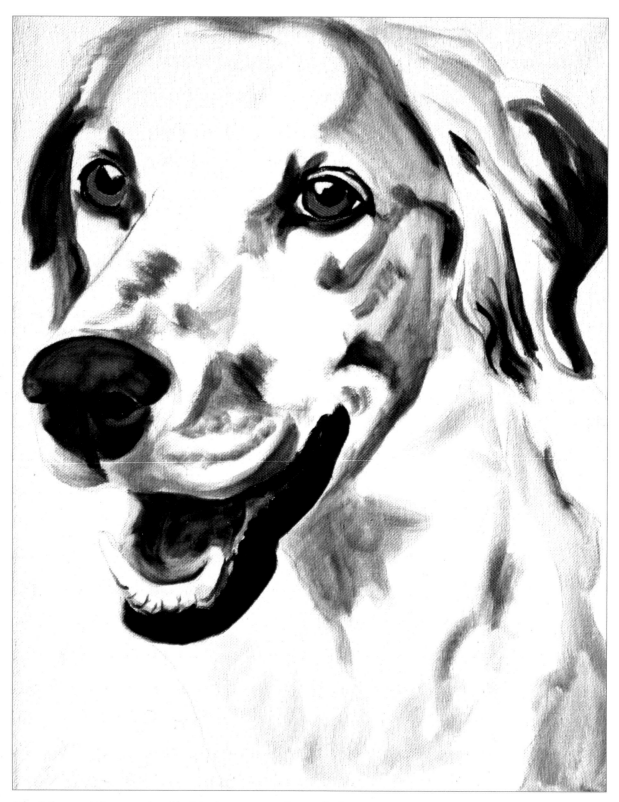

Step 4 I use cadmium orange to block in the orange patches on the face, as well as add bright color to the eyes.

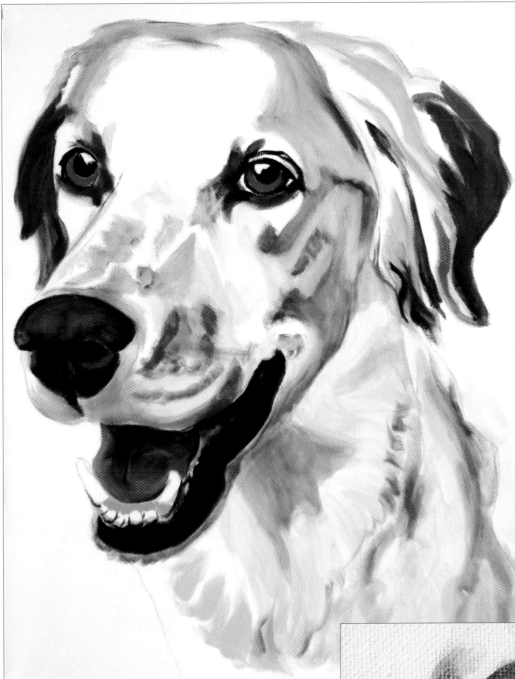

Step 5 I use powder blue for the midtone shadows. To delineate shadows, I go over the purple with a thinner, translucent powder blue, creating a light glaze that lets the color underneath show through. I use thicker paint where needed, creating a nice range of midtone values for the shadows. Then I apply light portrait pink, thick on a dry brush, to block out the gums and the lights on the tongue. Using light magenta, I glaze over the light portrait pink on the tongue, leaving the lightest lights. With thin paint on a dry brush, I add accents to the fur on the neck, ear, face, and around the eyes. Once the tongue is dry, I darken shadows with thinned dioxazine purple and quinacridone magenta in glazes.

Step 6 I add dimension to the irises with burnt sienna straight from the tube on a dry brush, blending at the edges.

Step 7 I add highlights, using titanium white, on the tongue, nose, lips, and eyes, which make the portrait come to life.

MAKING ADJUSTMENTS

I initially outlined Cheetah in cadmium orange to make her stand out from the background. After it dried, I realized it was way too vibrant and competed for attention. Things like this happen sometimes in painting; you make a design choice, and it doesn't work. The nice thing about acrylic is that it dries quickly, so I just painted over it with light blue.

Step 8 I darken the lips, nostrils, and pupils. Then I brush on a thick background of cerulean blue and brilliant blue with a moistened brush, using darker blue on the bottom and lighter blue at the top. I initially paint Cheetah's outline in cadmium orange, but it is a bit too bright. Once it dries, I paint over the orange with light blue to tone down the vibrancy so that it doesn't compete with the figure (see "Making Adjustments" on page 118). I make a few touch-ups for a final polished look, and the portrait is finished!

Labrador

This sweet labrador named Olive is perfect for a painting with a *low-key*, or dark-value, subject. Painting a low-key subject starts the same as a high-key subject, but the lightest parts of the portrait will be the highlights in the nose and eyes.

COLOR PALETTE

brilliant blue, burnt sienna, cadmium orange, dioxazine purple, light blue, manganese blue, quinacridone violet, titanium white

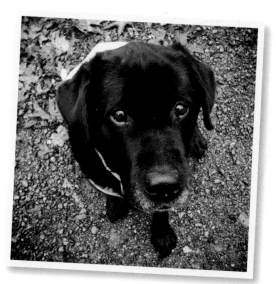

ARTIST'S TIP

Pay attention to soft and hard edges; it's important to know the difference! Hard edges usually occur around the eyes, nose, and mouth. On a shorthaired dog like Olive, shadows and lights blend the soft edges into an illusion of furry texture.

Step 1 I sketch Olive onto the canvas. I like to fill the canvas with the subject, so that the face is the dominant feature. I block out the darks and lights, which fit together like a jigsaw puzzle.

Step 2 I start with dioxazine purple, mapping out the dark and light values. For the midtone values, I thin the color by adding paint to the brush directly from the tube and then dipping it in the water, draining the excess before putting it on the canvas. For the darkest values, I use paint directly from the tube. I make sure my brushstrokes follow the fur growth, and I leave the canvas bare for the highlights.

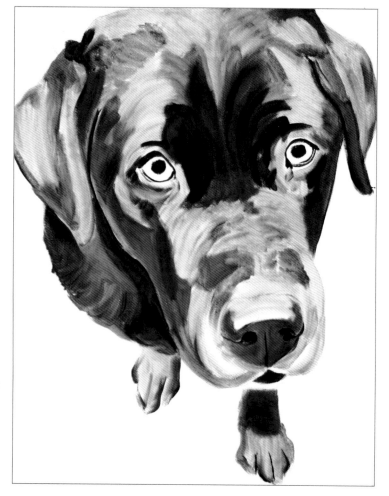

Step 3 I use quinacridone violet to warm the darks, as well as add initial color to the irises of the eyes.

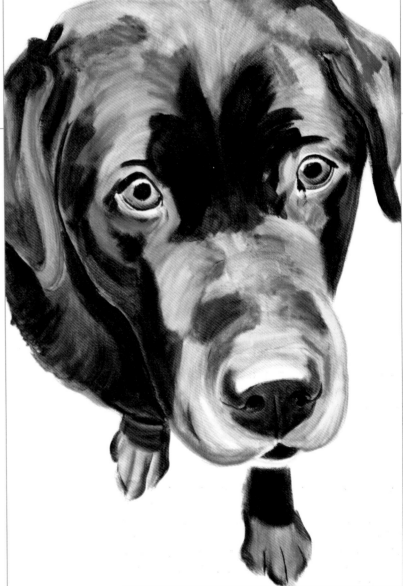

Step 4 I use manganese blue to glaze over the lights in the face, ears, and paws. Thinning the paint with water allows the purple underneath to show through. I use more opaque paint for value and color variation.

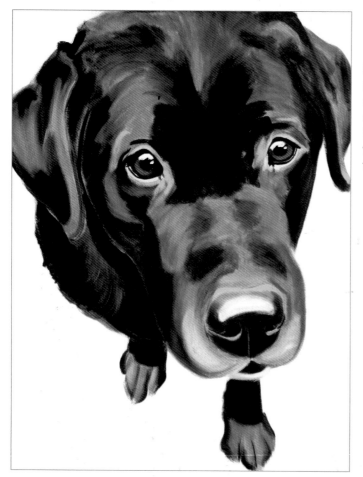

Step 5 I use brilliant blue over the initial glazes to add opacity, but I leave the darkest shadows alone. I use manganese blue again on the top of the head to add fur texture, leaving the brushstrokes visible. Then I use light blue to outline and highlight the eyes, as well as well-blended strokes on the muzzle to suggest the silver hairs around the nose and mouth.

Step 6 Over the irises, I cover the initial quinacridone violet with burnt sienna. Then I add another glaze of quinacridone violet to add shadow dimension, which rounds the eyes.

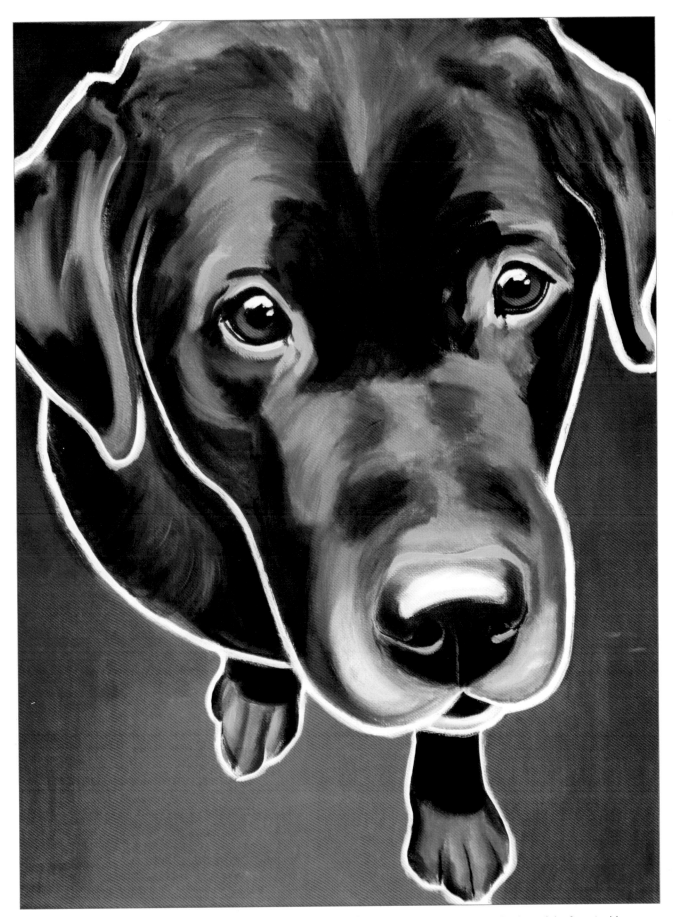

Step 7 I add cadmium orange as a lighter value on the irises to make the eyes "pop" against the cool colors of the face. I add a warm background to contrast with the cool subject, blending quinacridone violet from the top of the canvas into cadmium orange toward the bottom. Then I add a titanium white outline around Olive to smooth the edges, as well as add visual interest. I make final touch-ups, such as darkening the pupils, nostrils, and darkest darks and adding white where needed: the highlights in the eyes and nose, and a thin glaze over the lightest lights in the fur.

Beagle

For this painting, I wanted to find a good face that would allow me to use very light and very dark values. This beagle cross, named Lady Baillee, is the perfect candidate with both black and white on her face. This sweet little pooch also has beautiful eyes, which are a challenge to capture, but it is very satisfying when you do. I use just three brushes for this painting—#2 bright, #6 bright, and #12 bright.

COLOR PALETTE

brilliant blue, brilliant yellow green, burnt sienna, cadmium orange, cadmium yellow deep, cadmium yellow light, dioxazine purple, powder blue (ultramarine blue + titanium white), quinacridone violet, titanium white

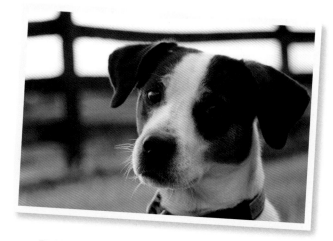

Step 1 First I make a graphite sketch directly on the canvas. I don't worry too much about capturing every single detail; I just make sure it's proportionally correct and that I have delineated where the value changes will be. I use the reference photo as my value study.

Step 2 Painting is an intuitive and spontaneous process for me, so I don't plan out my palette ahead of time. I also don't use a mixing palette to paint; instead I squeeze the paint directly onto the brush or the canvas and mix it there if necessary. I always start with the darkest values and work toward the lightest. Using dioxazine purple, I map out the darkest values. The painting will build up in transparent layers, or glazes, so I don't aim for perfection at the beginning. I put paint from the tube directly onto the brush and then dip the brush in water. I dab the brush on paper towels to remove excess water. If the paint runs, I just wipe it away. Then I use big, broad strokes to fill in the appropriate areas of the sketch. I use a smaller brush to define the edges of the eyes, nose, and mouth. I go over the darker areas more than once, but the lighter parts need only one pass.

Step 3 I use quinacridone violet to paint in the darkest parts of the reds on the face, the reflected light under the ears, and some of the shapes on the neck. I use thicker or thinner paint, depending on the value needs. I also use this color to begin the eyes, using a very thin wash.

Step 4 With cadmium orange, I fill out the patches on her face, define some of the chin, and add to the shapes on her neck. I use thicker paint for the face patches and keep the brush damp, but not dripping. I paint over the quinacridone violet in the patches as well; it is quite transparent, so the shadows are still visible. I start to define the white fur with powder blue, still working very loosely and spontaneously. I use powder blue to begin the highlights on the nose, eyebrows, chin, and lip.

Step 5 I use my smallest paintbrush (#2 bright) with burnt sienna to make the eyes more opaque. Then I add quinacridone violet in the top corners of the eyes, where there are usually shadows from the brow. The eyes are very important, but I try to maintain the spontaneity of the process even when detailing with the smaller brush.

Step 6 Next I use cadmium yellow light to add some interest on the nose, muzzle, and neck. I also use this yellow to highlight the orange patches. Since the purple is dry now, this is a good time to add more layers to the darks, creating more opacity. I go over the nose again with dioxazine purple, as well as the dark part of the muzzle.

Step 7 I apply cadmium orange to the bottoms of the eyes to create depth. Then I brush brilliant blue over the eyelids to begin the highlight and define the lighter portions of the lids and brows. I paint the whites of the eyes and add highlights with powder blue. I add definition to the nose, accents on the edge of the ear, and highlights in the dark fur with brilliant blue. I squeeze brilliant blue directly on the canvas to create a thick, flat color field for the background.

Step 8 I study the details, making sure the edges are soft where they need to be and hard where they need to be. I add another layer of highlights, especially on the nose. I don't try to blend my brushstrokes; the visible strokes provide interest. I finish the background with cadmium yellow deep and brilliant yellow green, which is an equivalent of mixing phthalo green, cadmium yellow, and white. These colors harmonize well with the face, since the transparent glazes move through each other and create new colors and shades. I use white to outline one side of the head and green to outline the other side, making Lady Baillee pop from the canvas. I check for any final details that might need touching up before calling my painting complete.

Giraffe

I love this giraffe's funny face! Usually a giraffe's long neck is the highlighted feature, but its face and head are also very distinctive—and really fun to capture! As you work on this fun giraffe portrait, remember to pay attention to values. You can create dimension by painting lights and darks in the right places: a long nose will come forward in space, eyes will look more round, and lips will become plump and fuzzy. The painting will come to life!

COLOR PALETTE

azo yellow, bright aqua green, cadmium orange, cadmium yellow deep, cadmium yellow medium, dioxazine purple, powder blue (ultramarine blue + titanium white), quinacridone violet, titanium white

Step 1 I start with a pencil sketch of the subject. I like to fill the canvas from edge to edge, so I make sure the tips of the ears touch the edges of the canvas. I don't worry about capturing all the details; I just need to know where the different values are.

Step 2 Using dioxazine purple, I block in the darkest values: the eyes, ears, mouth, nostrils, and shadows. Where the values are darkest, I use thicker paint; where they're slightly lighter, I thin the paint with water. This layer dries quickly, and I go back over it to add another layer of quinacridone violet on the snout, lips, horns, ears, and forehead. I just put a little paint directly on my brush from the tube and dip it quickly in water to thin.

Step 3 I add cadmium orange to a wet brush and paint the horns, forehead, nose, and lips. Notice that the paint is thick. I also lighten the spots on the neck.

Step 4 Since I'm working from dark to light, my next layer is cadmium yellow deep, which I add to the snout, forehead, ears, and neck. Again, I use paint directly from the tube. After this layer dries, I use azo yellow to add some lighter values.

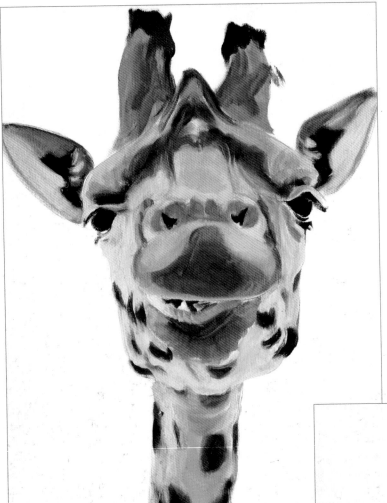

Step 5 Using a moist brush, I use bright aqua green directly from the tube to fill in the cheeks and neck, with some patches on the ears and above the eyes. Because the paint is thin, the white of the canvas peeks through. I use thicker paint on the neck, which is shadowed.

Step 6 I use powder blue to tame and lighten the aqua green throughout the piece. I use a pretty thick layer of color, but since it's semi-transparent, the aqua green still shines through. I leave some of the green untouched to add some vibrant punches to the piece, especially on the neck, lip, and eyebrows. Then I put titanium white straight from the tube on a wet brush and add the highlights on the nose, forehead, ears, and neck. I also use white to add some shape and texture to the cheeks.

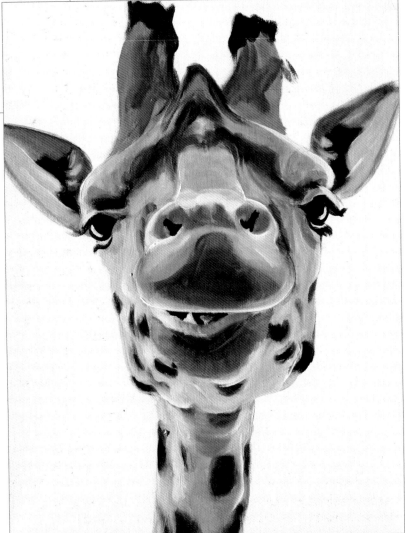

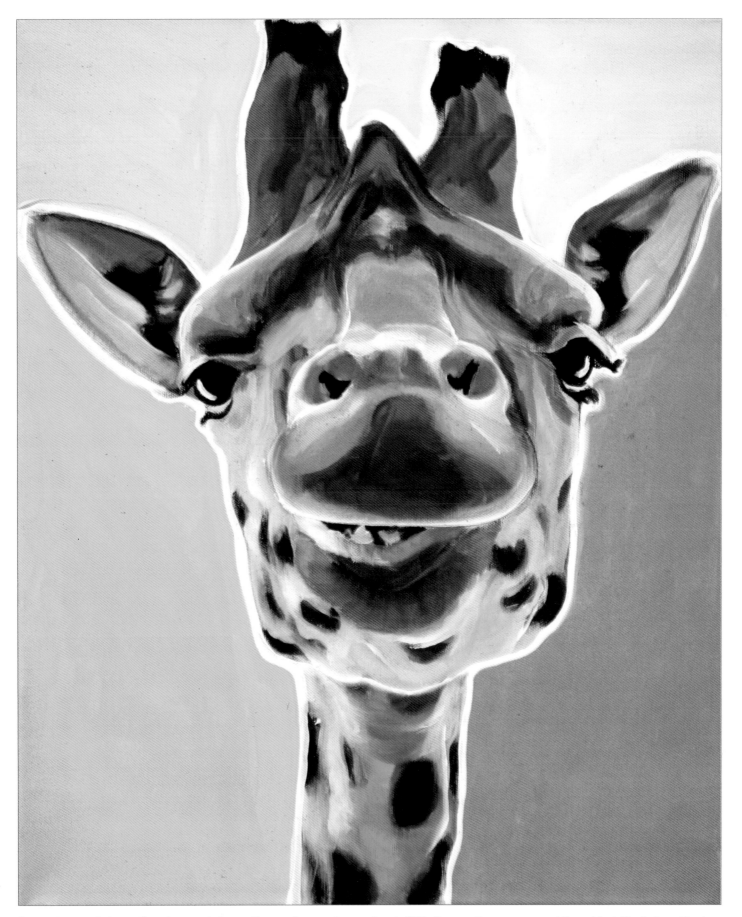

Step 7 I use cadmium yellow deep, cadmium yellow medium, and azo yellow to fill in the negative space around the subject. Finally I use titanium white to outline the subject and make it stand out from the canvas.

Elephant

Elephants are fascinating creatures—huge and full of personality, surprisingly sophisticated in their social patterns and relationships. I thought it would be interesting to focus on an elephant's face and do a study of the interlocking lines and shapes of their wrinkles, as well as play with patches of color.

COLOR PALETTE

bright aqua green, brilliant blue, brilliant purple, cadmium yellow deep, cadmium yellow light, dioxazine purple, light blue permanent, manganese blue, medium magenta, titanium white

Step 1 After sketching the elephant on the canvas, I use dioxazine purple to block in the darks. Other than the wrinkles there aren't many—just a few darker values around the eye and mouth, which will be important landmarks as I begin to add color.

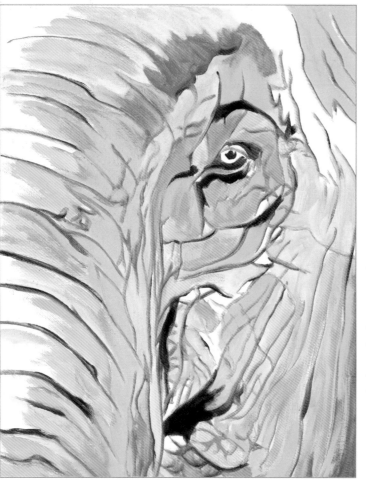

Step 2 I put manganese blue straight from the tube on a damp brush and block in a few shadow areas. Then I use bright aqua green to block in lighter shadows, painting right over the purple wrinkle lines. I use brilliant blue to darken the side of the trunk and around the eye and mouth. I fill in a few more wrinkle shapes with brilliant blue. Then I use cadmium yellow deep to start the transition into the light side of the face. I use yellow around the eye and in some of the wrinkles lower on the face, filling in some white spaces and going over a few aqua or blue spots to make a muted yellow-green. The colors definitely pop next to each other.

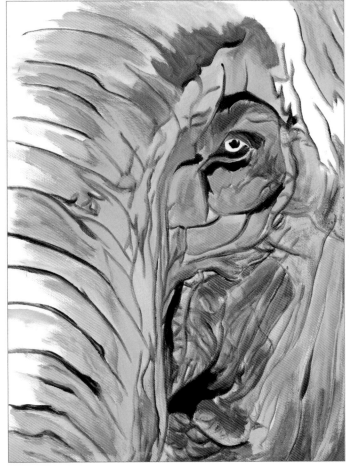

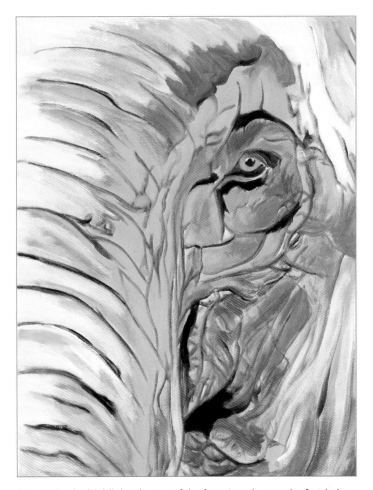

Step 3 I put medium magenta straight from the tube on a damp brush and fill in the rest of the white shapes around the eye and mouth. I also drybrush medium magenta across a few shapes already filled with blue and yellow, creating a wider variety of colors.

Step 4 On the highlighted areas of the face, I apply a wash of cadmium yellow light. While I wait for it to dry, I use brilliant purple on a damp brush over the magenta. Since this is a very opaque color, I don't use too much. I don't want it to overpower what is already on the canvas. I use titanium white to generally lighten the yellows on the trunk and forehead into a more pleasing tint. I also bring the white into the cadmium yellow deep on the cheek. I block in the iris with brilliant blue.

Step 5 I use a #2 bright to go back over the wrinkles and dark values with dioxazine purple, emphasizing and bringing them back out from behind the washes of color. Now the painting feels more cohesive. I also finish the eye (see "Eye Detail" below).

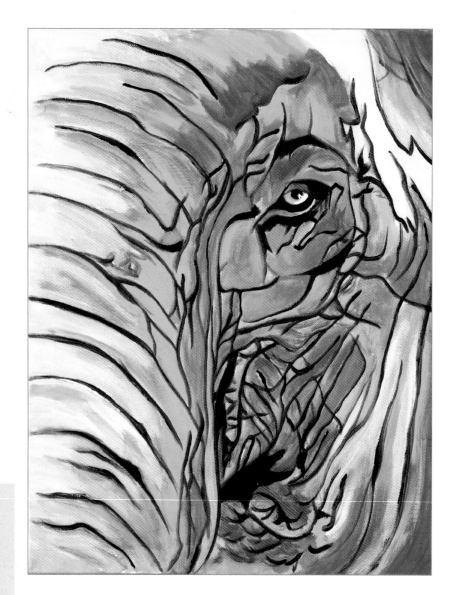

EYE DETAIL

I swipe a dab of light blue permanent over the brilliant blue on the bottom of the iris. Then I add a crescent of titanium white in the iris and a little dab in the pupil to create the perfect highlight. The fun jostle of colors and washes mixing to create new colors is especially evident here around the eye.

ARTIST'S TIP

Don't forget to step away from your canvas, especially with a painting like this; it's easy to get lost in the details. Step back from the easel every few minutes. This way you can correct any problems early on. It's good to take a break from painting as well. Go for a walk, drink some water, play with your dog—when you come back you may see something you've been missing!

Step 6 I lighten the top right corner, which feels too dark, with brilliant blue and add wrinkles back in. In contrast, the lip on the bottom corner of the mouth feels too bright, so I calm it with brilliant purple. This helps bring the focus back to the elephant's bright blue eye. I check the overall details, clean up with final touches, and my painting is finished.

Zebra

Zebras are fun to paint, with the pattern of stripes and the play of light-and-dark values. You can choose to put variations of color in the darks and keep the lights white or you can create flat, dark-valued stripes and put color in the lights. I decide to go with the second option. You might even want to try painting the zebra stripes in multiple colors in chromatic order!

COLOR PALETTE

bright aqua green, cadmium yellow deep, cadmium yellow light, cobalt turquoise, dioxazine purple, powder blue (ultramarine blue + titanium white), titanium white

Step 2 I block in the darks with dioxazine purple using #6 and #2 brights, depending on the size of the stripes. Purple will function as the black in the stripes. I paint it on thick for the dark stripes. I thin it with a little water around the muzzle and ears, where there is more variation, to denote texture and form. Highlights and shadows can be suggested with very little effort. A good value underpainting creates a helpful foundation for the rest of the project. Use paper towels to mop up any drips.

Step 1 First I sketch the subject, marking the black stripes. Note that if you fill the stripes with dark pencil on the canvas, your color might end up muddy as it picks up the graphite.

ARTIST'S TIP

Edges are very important for this subject. Clean edges will help create eye-catching contrast between the black-and-white stripes. Make sure your brush is wet enough to keep your edges smooth. If you make a rough edge, use a brush filled with water (but not dripping) to smooth the wet paint or lift it away.

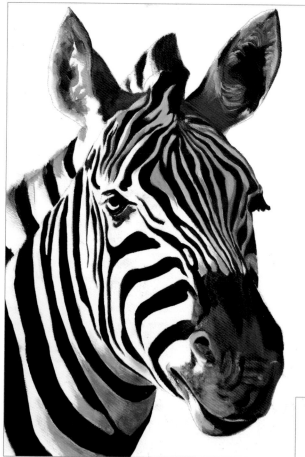

Step 3 I use a damp #6 bright with cobalt turquoise to block in the shadow side of the whites, as well as the reflected lights in the darkest darks. I start to fill in some of the white stripes with bright aqua green and work on the next lightest darks by highlighting the nostril, blending the hair in the ears, adding creases in the velvety muzzle, and adding to the soft edge in the cobalt turquoise on the shadow side of the neck. Then I add cadmium yellow deep to some of the white stripes on the shadow side of the face, the ears, and the edge of the mane, blending out to white on the neck. I like the contrast of color between the green and orange.

Step 4 I use cadmium yellow light to fill in most of the rest of the white spaces, as well as the edges of the ears. The paint is opaque, as I don't want too much of the white peeking through. I go over a few of the aqua stripes and in the ears to create a more vivid green.

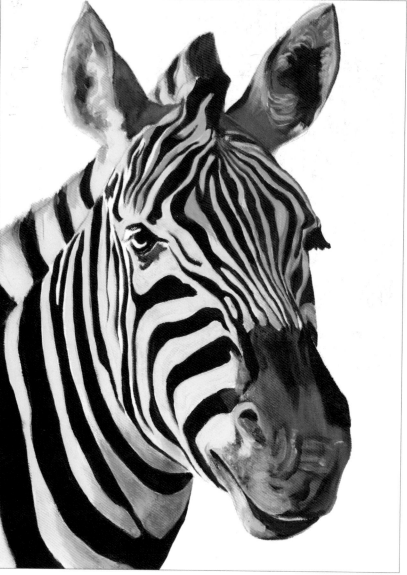

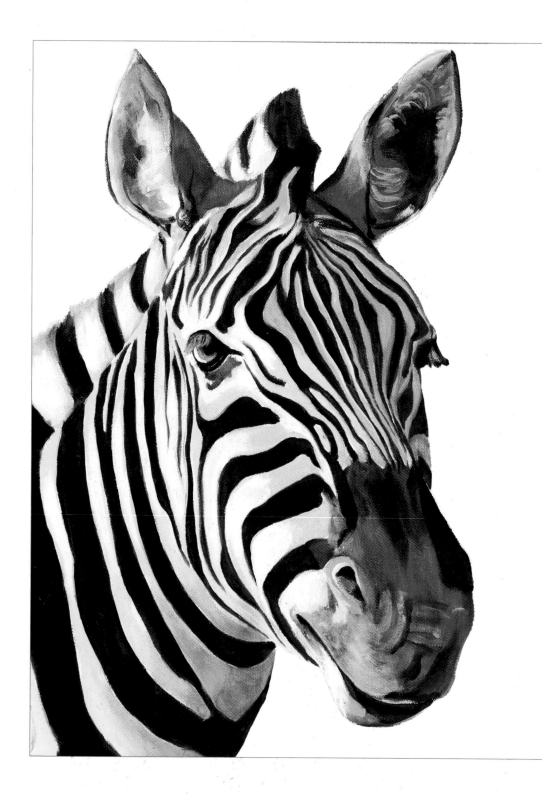

Step 5 I use titanium white, thinned with water, to add highlights on the sunny side of the face and to create form. I add touches of white on the cheek, neck, and mane, as well as around the eye and the lip. Then I warm or cool the stripes on the shadow side of the face. On the aqua stripes, I apply a thin layer of yellow. On the yellow stripes, I apply a thin layer of aqua. This creates both color variation and harmony in the face. Using a dry brush, I use powder blue to lightly add dimension to the mane. Then I touch a little more powder blue here and there around the face to relate it throughout the painting. I paint the eye aqua green with a white highlight. Then I paint the lashes on the light side by drybrushing aqua with yellow on top; on the shadow side, I highlight the lashes with aqua.

ARTIST'S TIP

If you use a color in only one place on the painting, it stands out and becomes an eye trap. Make sure your color use is purposeful.

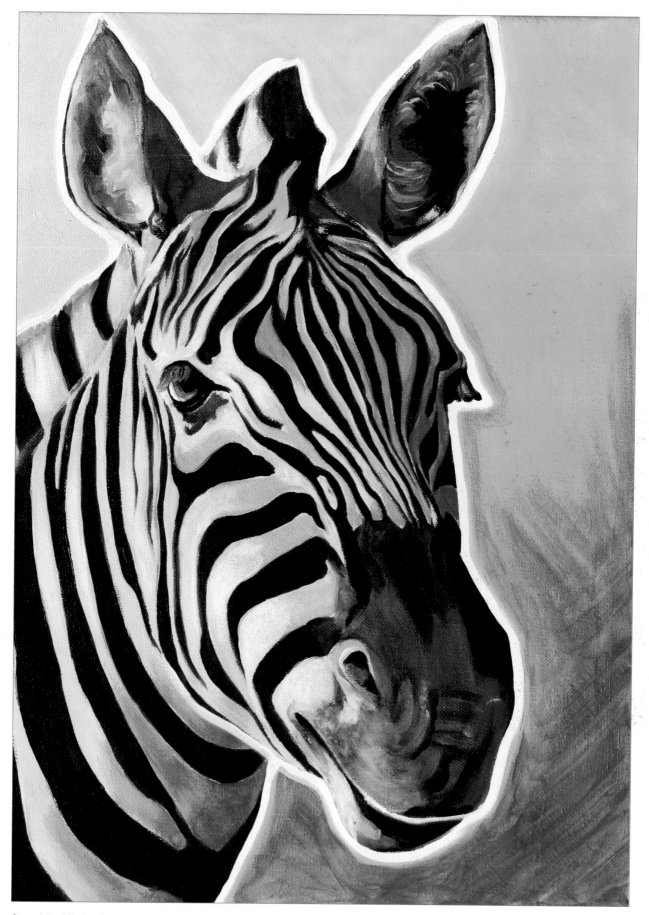

Step 6 I add a background, using colors that I used in the zebra: powder blue, a mix of powder blue and aqua green, and aqua green with a bit of cobalt turquoise. I wet-brush over one corner for visual interest. Then I paint a graphic white line around the zebra to punch the shape of the subject out from the background. I make sure all the details are complete, and then I set the painting aside, coming back to it later to see if any additional finishing touches are needed.

About the Artists

Alicia VanNoy Call, creator of DawgArt, specializes in pet portraiture and animal art on canvas. Her paintings are inspired by the vivid colors of the desert Southwest, where she lives and works in Arizona. Alicia is an award-winning writer and illustrator and holds a BFA in illustration from Utah Valley University. Her art is found in fine retail establishments across the United States. To see more of Alicia's art, visit www.dawgart.com.

Michael Hallinan is equally comfortable painting the figure and landscapes. While a major portion of his work consists of commissioned portraits, he also paints the California coast and Hawaiian islands. Michael's paintings have graced the covers of several national publications, and he is a 20-year exhibitor at the Laguna Beach Festival of the Arts. Michael lives in Laguna Beach with his wife Cathy and Nina Marie, the wonder dog. To learn more about Michael, visit www.michaelhallinanstudio.com.

Varvara Harmon is an award-winning multimedia artist who works in oil, acrylic, watercolor, silk paintings, and ink and pencil drawing. Her work has been juried into national and international exhibitions, is in private collections around the world, and has been published in several magazines and books. Varvara is currently represented at several galleries across the Northeast, and she teaches workshops and classes in acrylic, watercolor, and oil. Visit www.varvaraharmon.com to learn more.

Darice Machel McGuire lives, paints, and teaches acrylic and oil painting on the beautiful island of Maui, Hawaii. Her Hawaii and California landscape and seascape paintings grace the homes and offices of collectors nationally and internationally. Darice's choice of subject matter comes from her love of nature and all that surrounds her on a daily basis. Her work is represented in three galleries on Maui. To learn more about Darice, visit www.daricemachel.com.

Toni Watts is a former doctor who gave up medicine to follow her dream of being an artist. Her award-winning work is now held in private collections worldwide, and she splits her time between painting, teaching, and watching the wildlife she loves. Visit www.toniwatts.com to learn more.

Linda Yurgensen is a self-taught contemporary artist who paints primarily in acrylic and oil. She is known for painting the familiar "stuff" in daily life. Linda has found her love to be in still life. Light, color, and composition are all vital elements integral to her work. To see more of Linda's artwork, visit www.cobblehillstudio.blogspot.com.

Index